Backdrops AND Backgrounds

A Portrait Photographer's Guide

Ryan Klos

AMHERST MEDIA, INC. ■ BUFFALO, NY

Dedication

For my wife, Monica, who provides encouragement and motivation for all my creative endeavors.

Published by:
Amherst Media, Inc.
P.O. Box 586
Buffalo, N.Y. 14226
Fax: 716-874-4508
www.AmherstMedia.com

Publisher: Craig Alesse
Senior Editor/Production Manager: Michelle Perkins
Assistant Editor: Barbara A. Lynch-Johnt
Editorial Assistance from: Carey A. Miller, Sally Jarzab, John S. Loder
Business Manager: Adam Richards
Marketing, Sales, and Promotion Manager: Kate Neaverth
Warehouse and Fulfillment Manager: Roger Singo

ISBN-13: 978-1-60895-536-7
Library of Congress Control Number: 2012936513
Printed in The United States of America.
10 9 8 7 6 5 4 3 2 1

Check out Amherst Media's blogs at: http://portrait-photographer.blogspot.com/
http://weddingphotographer-amherstmedia.blogspot.com/

Table of Contents

Introduction .6
Backdrops *vs.* Backgrounds8
The Subject is Always the Subject.10

SECTION 1
WORKING IN THE STUDIO11

1. Backdrop Fabrics and Materials11
Canvas. .12
Muslin and Cotton Blends.12
Backdrops from the Fabric Store13
Dealing with Wrinkles14
Polyester and Wrinkle-Resistance16
Vinyl .20

2. Printed, Painted, Scenic, and More21
Hand-Painted *vs.* Computer Painted21
Darkened Edges *vs.*
 Consistent Coverage.23

3. Seamless Paper24
Sizes .24
Simple and Efficient.25
Setup. .26
Versatility. .29
Storage is a Breeze.31

4. Studio Flooring and Floordrops32
The Sweep. .34
Permanent Floor35
Artificial Floor/Floordrop36
Baseboards. .39
Hybrid Wall and Floor in One40

5. Producing a Pure White Background42
White Seamless Paper.43
Softbox Backdrop47
Other Methods .48

6. Cyclorama Wall49
Benefits .49
Lighting .50
Maintenance .51
Is It Right for You?52

7. Producing a Pure Black Background53
Backdrop Color.53
Distance .54
Lighting and Flagging55
Postproduction Cropping56

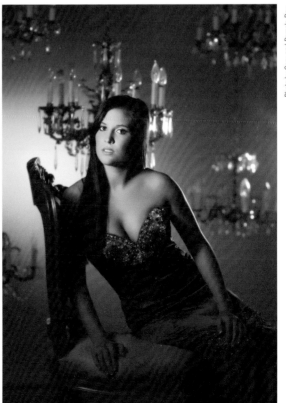

Photo by Gary and Pamela Box.

8. Digital Backdrops and Composites58
Chromakey Backdrops............59
Lighting the Subject59
Chromakey Removal61
Digital Backdrops61
Are Digital Backgrounds Right for You?....63

9. Portable Backdrops64
About Portable Backdrops..........64
Benefits.....................65
Collapsible Backdrops66
Don't Forget DIY66
One Last Option68
Portable Backdrops to Check Out68

10. Lighting the Backdrop............69
Use a Meter...................70
Light the Subject and Backdrop
 Independently70
Light Positioning...............70
Light Modifiers72

11. Setting Up Backdrops75
Two-Stand Options76

One-Stand Options77
Expansion Drive Mounting System77
Motorized Roller Mounting System......78
Hanging Without a Roller System79

12. How to Choose a Backdrop80
Material and Wrinkles80
Storage81
Maintenance and Care81
Mobility83
Size83
Print and Patterns, Trends and Fads......84

13. Creative Backdrops..............89
Home Store Options89
Found Objects..................89
Dangling Props90
Design It Yourself92
There's No Right or Wrong............92

14. "Pro-pinions" on Studio Backdrops..................93
Shannon Sewell94
Gary and Pamela Box99
Jen Basford105

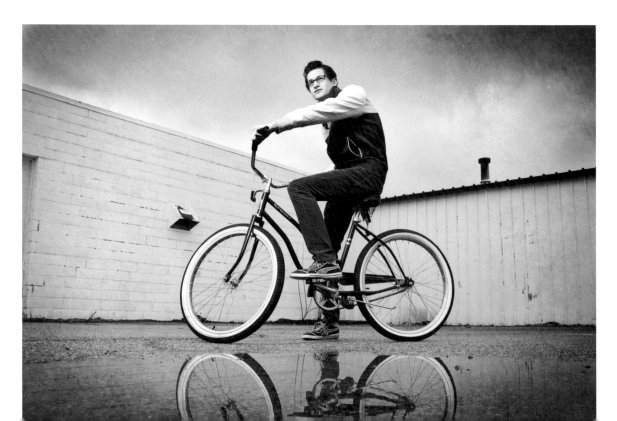

About the Author

Ryan Klos is a passionate photographer and writer whose career has taken him down a winding creative path working as a professional graphic designer, photographer, and writer. He has written for *Rangefinder* magazine, WBEZ Chicago Public Radio (NPR), the Lightroom-centric blog X= (www.x-equals.com/blog), and many other publications. He currently runs his own studio, Ryan Klos Photography, which specializes in senior portraits. Ryan lives in Woodstock, IL, with his wife, Monica, and two boys. This is Ryan's first photography book. Learn about Ryan and see more of his portrait work at www.ryanklos.com.

SECTION 2

THE WORLD IS YOUR STUDIO . . .109

15. Discovering Existing Backgrounds .109
Scouting Locations110
Cataloging Locations.110
What Makes a Good Location111
Transforming Any Location
 into a Good Location112
Changing the Appearance of a Location. . .117
Shooting Times .118
Same Location, Different Looks.119
Permission to Shoot.120
Popular Location Categories120

16. Architectural Backgrounds121
Defining Locations or
 Emotional Connections121
Composition and Framing124
Mood Swings. .126
What to Look For126

17. The Natural Landscape128
Seasonal Changes.129
Shooting at Any Time of the Day.130
What to Look For130

Trends. .132
Some Great Natural Location Ideas132

18. The Urban Landscape133
What to Look For134
Safety and Permission137
Some Great Urban Location Ideas.138

19. The Rural Landscape139
What to Look For139
Safety and Hazards143
Get Permission .143
Some Great Rural Location Ideas.144

20. "Pro-pinions" on Location Backgrounds145
Michelle Moore. .146
Shannon Sewell .150

CONCLUSION

Getting Uncomfortable154

Acknowledgments and Contributors . . .155
Resources .157

Index. .158

Introduction

If you put any two portraits next to each other they will have at least one thing (aside from a subject!) in common: a background. Whether it's a hand-painted muslin hanging in a studio or a forest of golden-leaved white birch trees, each and every portrait has a *something* behind the subject. It's not the main point of the photo, but it carries enough weight that it can make or break the portrait. If the subject and backdrop aren't well matched, it doesn't matter how well-lit or perfectly processed the image might be, the photo just isn't going to work. It will always have that "something's not quite right" feel to it.

When the subject and backdrop are well-coordinated, the photo is visually cohesive. Photo by Gary and Pamela Box.

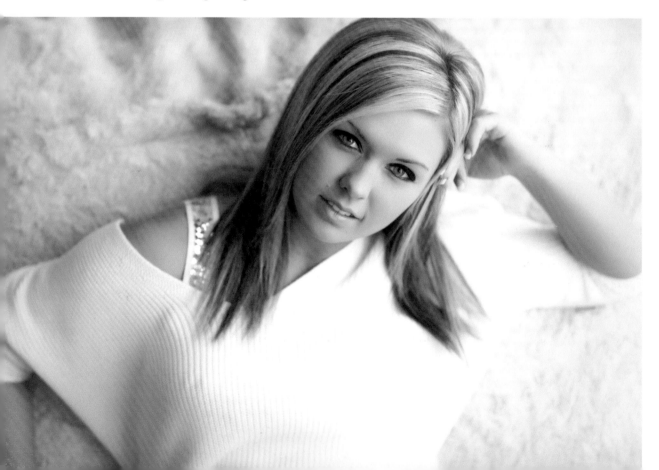

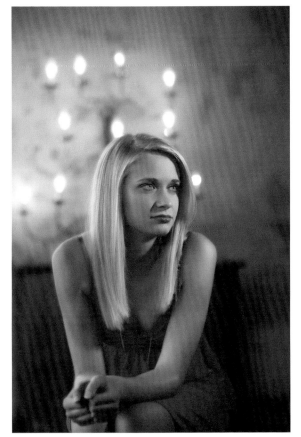

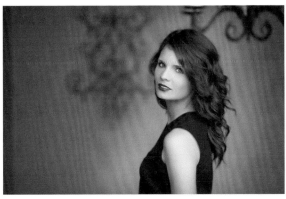

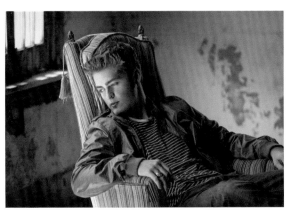

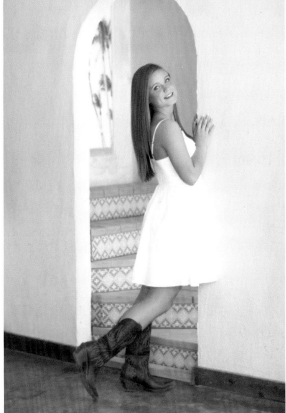

In addition to a subject, all portraits have something in common: some kind of backdrop or background. Photos by Gary and Pamela Box.

For example, I once shot a pre-prom event at a local high school where each couple posed in front of a small set and backdrop before boarding charter buses and heading out for a night of dining and dancing. The girls wore expensive gowns and many of them had obviously spent a small fortune on their hair, makeup, and nails. The guys wore tuxes to match their dates

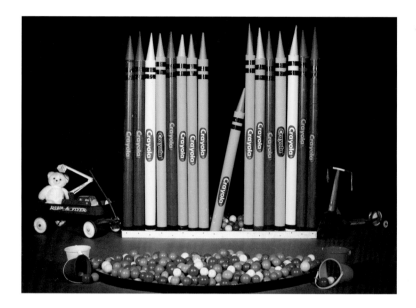

An unfortunately childish set for a high-school senior prom.

or to stand out from the crowd. These kids had spent a lot of time, money, and effort in making their prom an event worth remembering.

When I arrived at the school and saw the set and background where each couple would pose, my heart sank for these kids. The theme that year was "childhood memories," and the background was made up of stuffed animals, oversized crayons, and a ball pit. Behind this set was a huge backdrop of black mesh fabric. Imagine these beautifully dressed young men and women wearing their expensive gowns and tuxes posing in front of this background. It instantly diminished the elegance and maturity of the event— and quite possibly the morale of the students. In this case, the contrast of the subject against the background was jarring. I overheard several parents in the audience comment about how childish and inappropriate the setting and background were.

Happily, there are other times when the background is so seamless and perfectly suited to the subject that you can't imagine them anywhere else. That's what I strive for in the portraits I make—and it's a goal I encourage you to strive for as well.

In this case, the contrast of the subject against the background was jarring.

Backdrops *vs.* Backgrounds

For the purposes of this book, and to make sure we're all on the same page, when I'm talking about "backdrops" I'll specifically

be talking about materials you'd typically find hanging behind a subject in a studio portrait (muslins, seamless paper, vinyl, etc.).

I'll use "background" as a more general term when talking about the space and scene behind the subject. That scene could include a backdrop and props in a studio, a brick wall outdoors, or trees and a skyline.

I'll also mention studio sets in a few places. The main difference between a background and a studio set is props. My prom example was a studio set. Adding props as part of your background isn't a bad idea. In fact, it can add great variety and creative options for your clients. When I talk about adding props, I'll be talking about them as a part of the background—not as something for the subject to interact with, as is typical for many props and sets.

Here, the background is perfectly suited to the subject. Photo by Jacob Rohde.

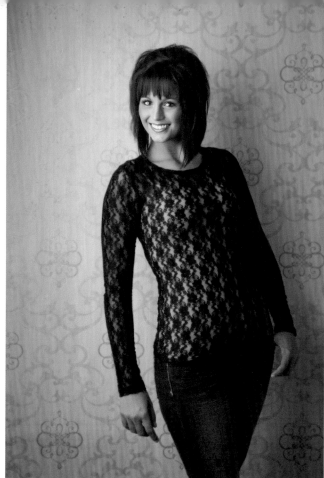

The Subject Is Always the Subject

I will talk a lot about backdrops and backgrounds in this book (that *is* its purpose, after all). I'll cover everything from choosing the right material for studio backdrops to learning how to find the right background on location. But don't get *too* caught up in backdrops and backgrounds; they are only one part of a portrait. While it's true that a good background can make or break a portrait, don't forget that the subject is always the subject. He or she is always the main focus of the portrait. The background is always secondary. Portraits have many parts that are required to make them successful, and the background is only one part. As a professional photographer you already know the rest of what makes a good portrait: posing, lighting, cropping, composition, etc. Now, let's get started.

No matter how simple or complex it is, the background should remain secondary to the subject. Photos by Gary and Pamela Box.

1. Backdrop Fabrics and Materials

A good photographer can use any type of material as a backdrop, but that doesn't mean he doesn't have a preference. Backdrop materials vary and there's really not one that's better than another. They all have their pros and cons—from wrinkles to price—so it's up to you to find your preference. Some of the more common materials are as follows.

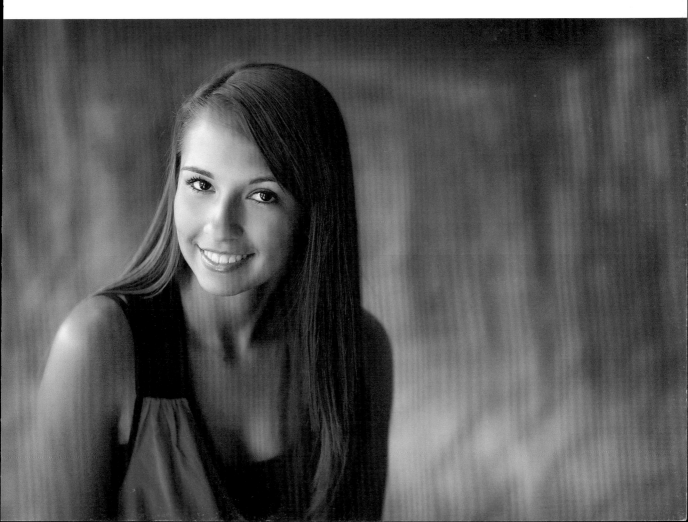

A colorful blue backdrop coordinated well with this subject's wardrobe, giving the image a cohesive look. Photo by Gary and Pamela Box.

Canvas

Canvas is a very traditional painting medium for artists. Because painted backdrops are desirable for portrait photography, this also makes canvas a natural choice for a backdrop material. Not only does canvas accept paint very well, it is also a very durable material that will last indefinitely when properly prepared and cared for. The only way to store painted canvas backdrops is rolled. Therefore, canvases are often used with motorized roller systems that are mounted to a wall or ceiling. These allow the canvas to be evenly rolled or unrolled for use or storage. (See chapter 11 for more on motorized roller systems.)

The color saturation and reproduction you'll get from canvas backdrops is second to none, which is why fine artists have used it for thousands of years. On the downside, it is very heavy and can be difficult to take on location. Additionally, wrinkles on a painted canvas are permanent because the paint is affected by the creasing. Canvas is also one of the most expensive backdrop materials you can buy, which deters many photographers from using it.

Not only does canvas accept paint very well, it is also a very durable material.

Muslin and Cotton Blends

Muslin is one of the most common fabrics used for photography backdrops. It is a cotton fabric with a fairly loose weave that is easily painted and holds dye very well, making it a popular choice for hand-painted backdrops. Compared to other more dense fabrics, it is also lightweight, so it travels well. But, like many cotton fabrics, it's prone to wrinkles. That's just the nature of cotton. Muslin is very durable, breathable, and relatively inexpensive compared to many other fabrics—so you don't have to shoot four portrait sessions just to pay for a backdrop.

Muslins and cottons are usually machine washable, but they can fade quickly and their colors may bleed when laundered. So even if the care instructions say it's okay to wash them, do so as infrequently as possible—or, to put it more succinctly, wash them only when it's absolutely necessary. To keep them from shrinking, most manufacturers suggest air drying muslins and other cotton backdrops. When they wrinkle, and they most certainly will, iron

Standard muslins give a traditional and professional appearance to business portraits.

A 10x12-foot muslin wadded up and ready to store.

them on the cotton setting with a standard iron or hang them up and steam them. (More information on steaming and removing wrinkles appears later in this chapter.)

Conversely, many photographers actually embrace the wrinkles on their muslins—and even encourage the formation of wrinkles by storing their backdrops wadded in balls. The texture of the wrinkles can add a pleasing visual effect to the backdrop—and after it's been used and stored for a few years, the wrinkles become soft and consistent. Besides, you could drive yourself nuts trying to iron or steam out wrinkles every time you wanted to use a muslin.

Backdrops from the Fabric Store

Another backdrop option is to use material from your local fabric store—just be sure you're buying a type that accepts light well. The last thing you want is to hang your fabric only to find it's too shiny and reflects a lot of light. Also, make sure the material you're buying isn't prone to wrinkles. There's no getting around it: 100 percent cotton is a 100 percent wrinkle-magnet. Try looking for

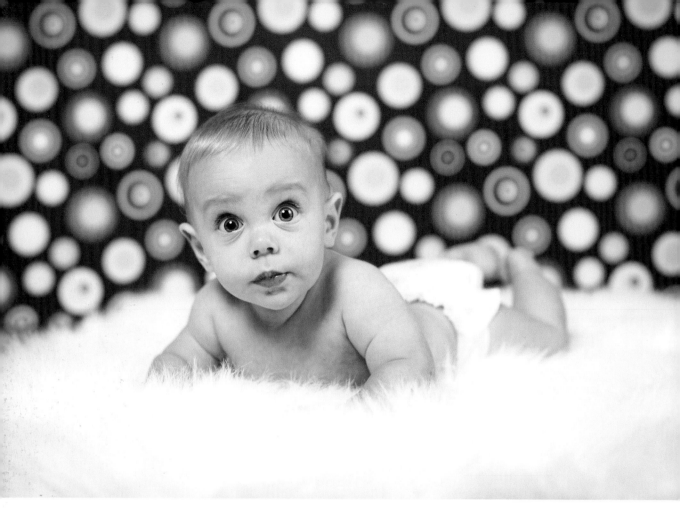

outdoor materials or heavier weaves like canvas. These will cost more, and you'll have a smaller print/pattern selection, but it may be a better option than spending countless hours steaming and ironing.

Fabric stores are a great place for children's backdrop patterns.

Dealing with Wrinkles

Wrinkles may or may not be an issue, depending on your backdrop storage method. If you don't want wrinkles and you have the space, the best way to store muslin backdrops is by hanging or rolling them. If wrinkles don't bother you, consider wadding the backdrops, as mentioned previously. Just gather the muslin into a ball and drop it into a pile, laundry basket, or sack. Some photographers prefer to store backdrops this way specifically to achieve the wrinkled look because it adds texture to the backdrop. The only drawback is this: if your subjects aren't

far enough away from the backdrop and you're using a small-ish aperture, the wrinkles will be more pronounced than you might like. This could draw attention away from your subject.

Wrinkles aren't specific to muslin and cotton blends. They're a fact of studio life no matter what kind of fabric your backdrop is made from—yes, even "wrinkle free" blends. Some fabrics resist wrinkles better than others, but when it comes to creases, any large piece of fabric folded up and stored on a shelf for a few weeks will show crease lines. The good news is you can combat wrinkles

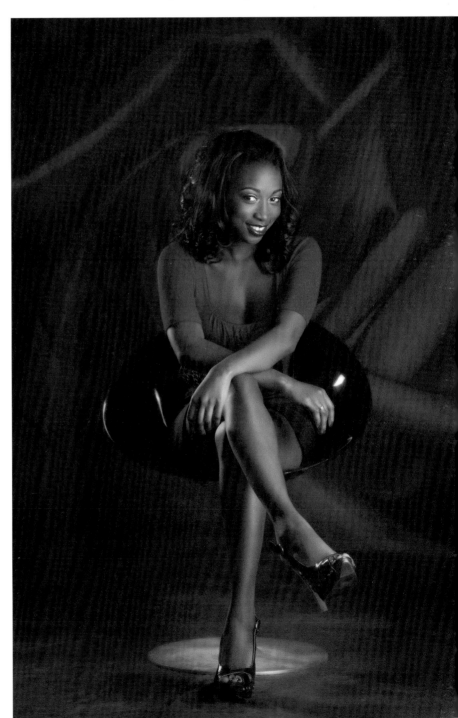

The wrinkles on this backdrop are consistent and subtle, exactly how you want them. Photo by Gary and Pamela Box.

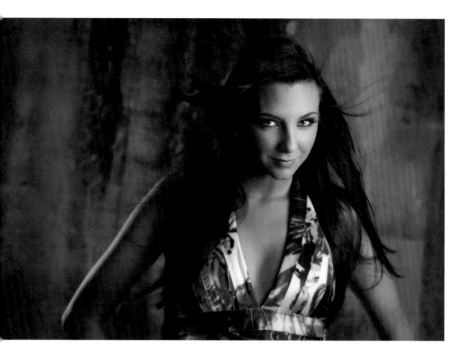

Letting the background fall out of focus reduces the visibility of any wrinkles on it. Photo by Gary and Pamela Box.

by ironing or steaming. Before you iron or steam any backdrops, however, make sure you thoroughly read the care instructions from the manufacturer. Some may not recommend ironing at all, while others may include temperature-setting suggestions.

Ironing a large backdrop is pretty unwieldy, especially on a typical ironing board meant for pressing clothes. An easier method for eradicating wrinkles is to use a handheld steamer. Just hang your backdrop as normal and go over it with the steamer to make those wrinkles disappear. Handheld steamers, or travel steamers as they're often called, range from $15 to over $100. Do your homework here and make sure the steamer you purchase is capable of extended use.

Ironing a large backdrop is pretty unwieldy, especially on a typical ironing board meant for pressing clothes.

Polyester and Wrinkle-Resistance

There's really no such thing as a wrinkle-free fabric, despite the claims of clothiers. All fabrics will wrinkle or crease if folded and stored for a long period of time. Wrinkle-*resistance* is another story.

One of the best wrinkle-resistant fabrics you can find for backdrops is 100 percent polyester. Polyester's synthetic nature keeps it from holding those wrinkles that plague muslin and

cotton blends. And, as an added bonus, it's very lightweight. Polyester isn't wrinkle-proof—it will still crease if folded and stored that way for long periods of time—but you can usually steam those wrinkles out with no problem.

Polyester can also be washed in your home washing machine, and in some cases it's safe to toss in your dryer on a low setting. (Again, be sure to read all care instructions specific to your purchased polyester backdrops.) Polyester also tends to hold its color better than some other fabrics after washing, but that doesn't mean you should wash it on a regular basis. Just as with any backdrop, polyester backdrops should only be washed when absolutely necessary.

Storing a polyester backdrop is easy because of the fabric's wrinkle-resistant quality. If it's not going to be stored for a long period of time, you can simply fold a polyester backdrop and store it flat. The longer it sits, the longer the creases will stay—but they can always be steamed out. Just as with muslins, if you have a studio space that is large enough, you can also keep your polyester backdrops hung all the time and never have to worry about a fold or crease.

These backdrops from White House Custom Color are made from a polyester-based material.

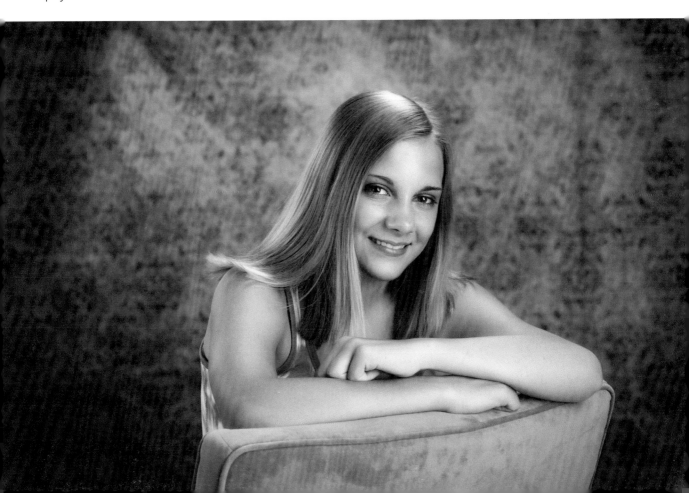

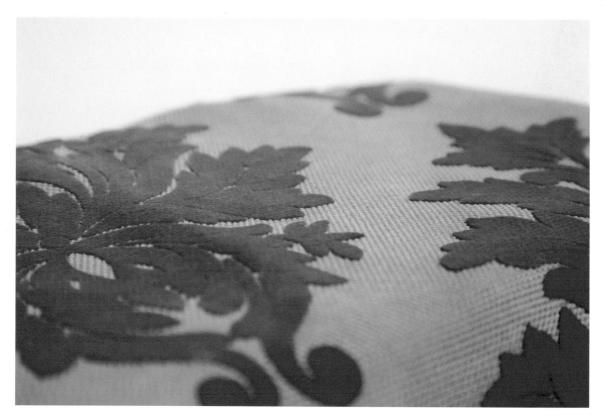

Another benefit of polyester backdrops is their ability to absorb light (as opposed to reflecting it), which makes for poppy color saturation. Some other backdrop fabrics may appear washed out or low in color contrast, but polyester accepts light very well and backdrop patterns and images printed on it tend to appear more saturated than on cottons.

Again, wrinkle-resistant fabrics are typically going to be made of polyester. However, you may have to read the descriptions of the backdrops you're looking at or even call a salesperson to determine if it's polyester. Maybe because the phrase "polyester backdrops" doesn't sound very appealing, manufacturers often create fancy names for their wrinkle-resistant backdrop lines. For example: Freedom Cloth (by Denny Manufacturing) and Platinum Cloth (by Backdrop Outlet).

Another wrinkle-free backdrop manufacturer, Drop It Modern, uses thick fabric with velvet flocking to produce patterned backdrops that photograph beautifully. The ground fabric on their classic line is a cotton chenille blend, while on their

ABOVE—Detail of the flocking on a Drop It Modern fabric backdrop.

FACING PAGE—Another Drop It Modern backdrop.

lightweight line it is a polyester–cotton blend. As you can see, the commonality of wrinkle-free backdrops is polyester. The thicker, heavier weave and inclusion of polyester make Drop It Modern's backdrops a great choice for photographers who are limited on space. Even when folded, these backdrops don't hold creases like many lightweight backdrops.

Polyester backdrops are lightweight, great at resisting wrinkles, and photograph beautifully.

Vinyl

Another backdrop material that is becoming popular is vinyl. It is very durable, and as long as it is not folded or creased it should remain usable for a long time. Vinyl is typically available only in solid colors—most often only black, white, gray, and chromakey green—and is used in much the same way as the same colors of seamless paper (more on this in chapter 3). It is available in long sheets and also on rolls. A noteworthy advantage of vinyl is that it is easily cleaned and is more durable; in contrast, once seamless paper is dirty, you simply remove and recycle the used portion. The other downside is that vinyl is more costly than seamless paper (in the short run)—but it's not out of range for most photographers. If you go through lots of rolls of paper each season, vinyl may be an option that's worth looking into.

If you go through lots of rolls of paper each season, vinyl may be an option that's worth looking into.

2. Printed, Painted, Scenic, and More

Backdrops come in all different sizes, patterns, gradients, and themes. From forest scenes, to geometric patterns, to Christmas trees and Easter eggs, the options are practically limitless. You could build a library of bricks or vintage looks if that's your thing. For photographers who specialize in team sports portraits, there are even backdrops made to look like stadiums, basketball courts, tennis courts, and other sports arenas.

Hand-Painted *vs.* Computer-Painted

The standard backdrops most associated with professional portraits are hand-painted ones. Hand-painting ensures the patterns will be varied throughout each backdrop and that no two backdrops are exactly the same (if that's a concern). Sometimes, a custom design may even be painted directly onto the studio walls.

An example of a scenic backdrop. Photo by Gary and Pamela Box.

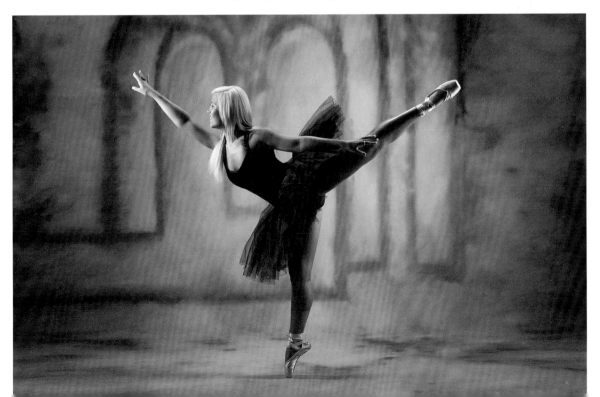

A hand-painted backdrop by Shooting Gallery Backgrounds. Photo courtesy of Shooting Gallery Backgrounds.

A computer-painted backdrop from Westcott. Photo courtesy of FJ Westcott.

Another approach is for the scene or pattern to be *printed* on the fabric. These backdrops, often called "computer-painted" offer a more photorealistic look—this is where you might see a Christmas scene or stadium, for example. For the computer-painted backdrops, you can choose from a manufacturer's catalog of images or even use your own photos. The image could be

entirely created using software like Photoshop, or it could be a photo of a hand-painted design that gets enhanced in Photoshop and then printed. Either way, the backdrop is printed onto a chosen substrate, usually one that is polyester-based.

Darkened Edges *vs.* Consistent Coverage

Some backdrops are brighter in the center (typically called a hotspot) and gradually darken toward the edges. Some are consistent across the entire width and height. Both have their advantages and uses.

Having darkened edges offers a very professional presentation for individual portraits, because the viewer's attention is automatically drawn to the subject. Not all portraits work with (or need) darkened edges, but it's another enhancement tool at your disposal. Also, you don't have to use a backdrop with the edges physically darkened to create this effect; you could always do it later in post-processing. As usual, though, the best and most realistic results are usually those you get right in the camera.

Many larger backdrops do not have darkened edges, which is just fine—because you never know how large of a group you'll be shooting against them. When shooting a group of multiple subjects, the focus isn't on any one single person, so there's no need to draw the viewer's eye to the center of the frame.

Having darkened edges offers a very professional presentation for individual portraits.

Hand-painted backdrop by Shooting Gallery Backgrounds. Photo courtesy of Shooting Gallery Backgrounds.

3. Seamless Paper

Seamless paper, a long length of paper rolled up like a huge tube of wrapping paper, is a studio staple for most photographers. It's called "seamless" because, when properly set up, it creates an unbroken sweep of paper from the vertical plane of the background to the horizontal plane of the floor. There's no visible seam or corner where the wall meets the floor.

Sizes

Seamless paper is available in dozens of colors and typically comes in two widths (4.5 feet and 9 feet) and a standard length

Yellow seamless paper added vibrant color to this portrait.

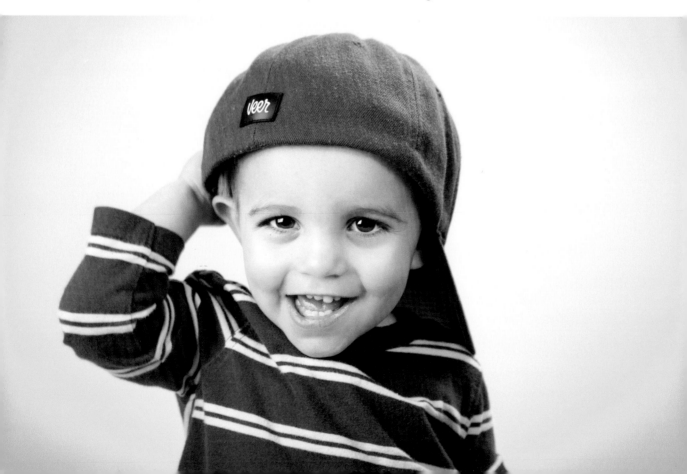

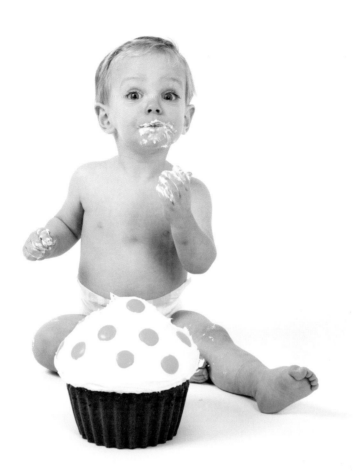

Seamless paper is great for smash-cake sessions because you can pitch the paper when you're finished and don't have to worry about the mess.

of 12 yards. The smaller width is great for headshots and smaller settings, but the larger roll will offer more options when setting up—especially as you increase the distance between your subject and the background. For either size, you can pull out as much as you want for length, but keep in mind that rolling it up could add crinkles or bends if it's not done properly and slowly.

Simple and Efficient

Seamless paper is one of the simplest backdrops to care for because you can roll it up when it's not in use—which means there won't be any wrinkles. Plus, when a section gets dirty, scuffed, bent, or torn, you can simply cut it off, recycle it, and pull down a new, clean section. If you're careful with it, you can reuse a section of seamless paper for many shoots—and an entire roll could last more than a year depending on what you're shooting. As you

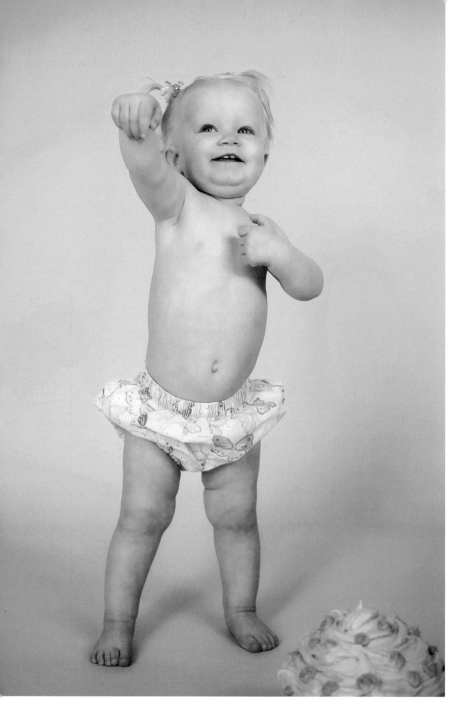

Pink seamless paper set the stage for this little girl's first-birthday session. Photo by Ravyn Stadick.

An advantage to using seamless paper is how quickly it sets up in the studio or on location.

might expect, however, if you specialize in pet photography it won't last quite as long.

Setup

An advantage to using seamless paper is how quickly it sets up in the studio or on location—usually on a standard background

stand consisting of two light stands with a crossbar between them. For studio applications, you can also use a mounted roller system fixed to the ceiling or wall. This allows you to pull down and roll up paper as needed. Most roller systems allow you to hang multiple rolls at a time, which is great when you have a few colors you use all the time, like black and white. Keeping seamless rolls on a roller system saves on wear and tear, too, because as soon as you're finished using a section you can roll it back up. Plus, you don't have to worry about clamps on the ends of the tube coming off or damaging your seamless.

Seamless roll on a standard two-stand setup. Photo courtesy of Calumet Photographic.

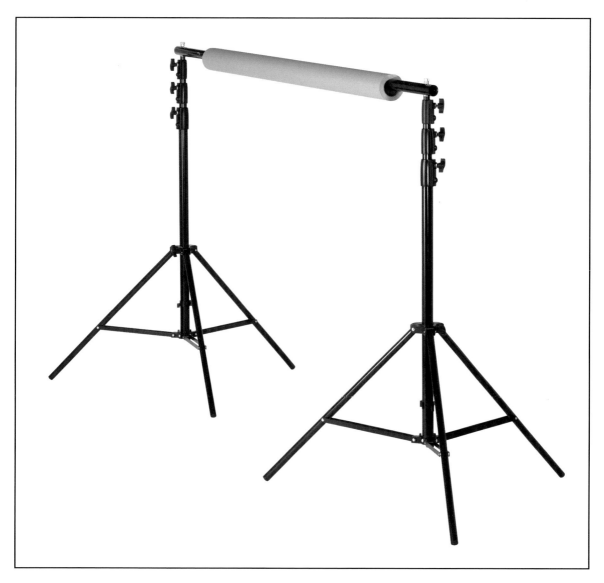

Here a green gel was used in front of a grid spot pointed at a black seamless backdrop to provide a green hotspot in the center.

A grid spot was pointed at light blue seamless paper to provide a hotspot in the center.

Versatility

Seamless paper photographs beautifully. It's also highly versatile because you can easily change its appearance. You can add or subtract light to change its tonality, or you can add gels to change its color. You can also add a hotspot for vignetting around your subject, adjusting the intensity of the hotspot to provide the desired gradient to the edges. Additionally, you can also use white seamless to shoot subjects with a pure white background (see chapter 5 for more on this).

One thing I like about white seamless, in particular, is that you can use it as a monochromatic backdrop—at tonalities all

the way from pure white to pure black. (For more about pure white seamless backdrops, see chapter 5.) The key is the distance between the lights and the backdrop. The farther away from the backdrop you place your subject and lights, the darker the backdrop will appear.

You can do the same thing for any other color of seamless paper as well. If you need the color to be more muted, move your subject and lighting away from the seamless. Again, you can also vary the intensity of the seamless color by adding a background light to create a nice tonal gradient of the original color.

In both of these photos, the backdrop was white. In the first (left), the distance between the main light and background makes it appear gray. In the second (right), a background light was added to create a subtle gradient.

Storage is a Breeze

Storing seamless paper is easier than many fabrics because it's supplied on a roll. When you purchase it, the roll comes in a tube—and you can store it in there when it's not in use. The only thing you need is floor space long enough to accommodate the length of the tube, or U-hooks mounted on a wall to hang them. For shorter lengths, you can store them vertically in a garbage can or just leaning up against a corner. When you're ready to use your seamless for a shoot, just pull it out and hang it. You don't have to worry about steaming out any wrinkles or washing it—if it's dirty, just cut off the dirty part and you're back to shooting. Seamless paper is as about as maintenance-free as it gets.

When you're ready to use your seamless for a shoot, just pull it out and hang it.

Storing seamless rolls can be as simple as leaning them in a corner or standing them up in a garbage can. Photo courtesy of Calumet Photographic.

4. Studio Flooring and Floordrops

Portraits come in all crops and sizes. Sometimes they're a tight head-and-shoulders shot, other times they're wide enough to see where the floor and background meet. Not all studios have the most photogenic floor, or one that works for every portrait, so let's look at flooring options that you can include in your portraits.

Including a floor in a portrait lends it authenticity and makes it feel less "portraity"—as if the subject is in a real place as opposed to a studio. A floor can also give the portrait more depth and dimension, and a more casual feel than a muslin-draped floor. Muslin-covered floors have their place, but when you introduce

Adding a faux floor is a quick way to change the look of your shooting area.

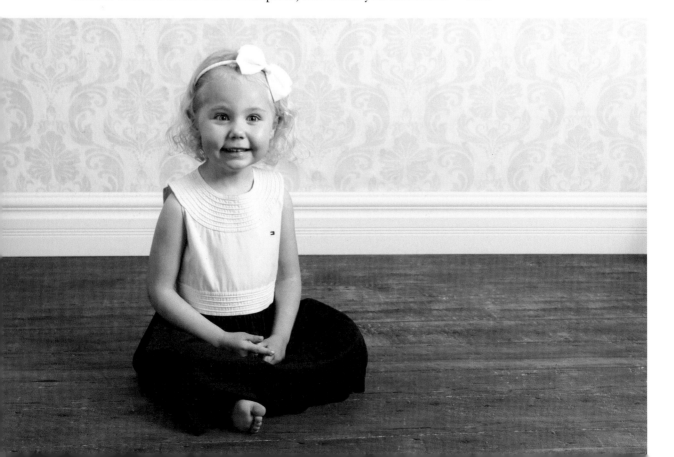

From a very high camera angle, the floor becomes the backdrop. Photo by Gary and Pamela Box.

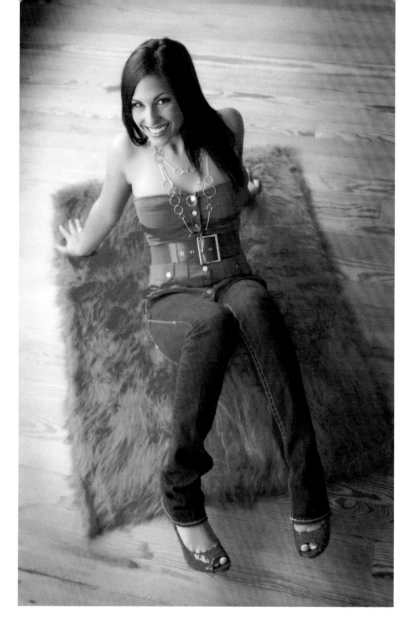

Including a floor in a portrait lends it authenticity and makes it feel less "portraity."

different flooring options, you open the doors to creative settings that could push you above your competition.

For those instances when the floor has to show (for the desired portrait length), or when you intentionally want the floor to show (for creative reasons), you have three options:

1. **The Sweep.** Make sure your backdrop is large enough to create a sweep and come out far enough to cover the floor where your subject is positioned.

2. **Permanent Floor.** Use the floor you have and hope it works with the subject and backdrop for the portrait you're making.
3. **Artificial Floor/Floordrop.** Lay down your own floor that appropriately complements your background and works with your subject.

The Sweep

Using a large backdrop as a sweep and posing your subject(s) on it is a fine option. It's very traditional and common, but also very limiting. I've had clients tell me they don't like the background sweep because it looks unnatural and makes them feel like they're floating in a sea of tonal colors. Yet, some photographers make the portrait work so well that you don't even notice it (the subject is the subject, after all). Like most things in the artistic world, it

Like most things in the artistic world, it ultimately comes down to personal taste.

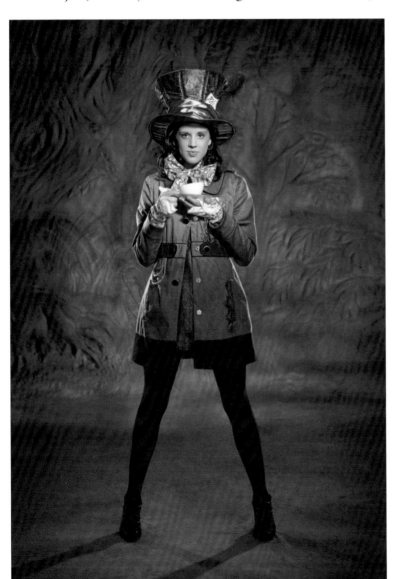

With some unique lighting and creative thinking, a sweep doesn't have to be boring. Photo by Gary and Pamela Box.

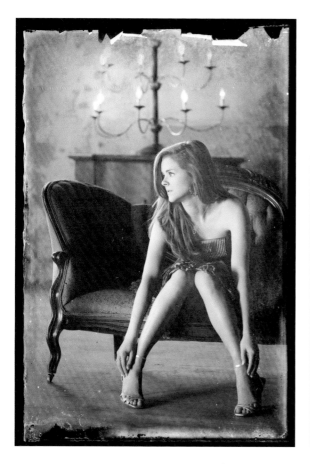

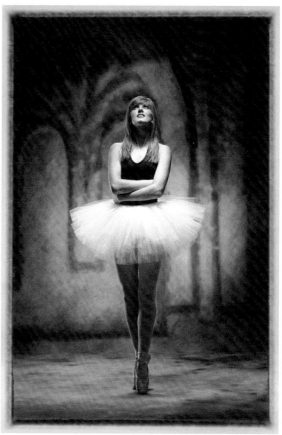

In the image on the left, the natural worn wood floor works well with the gritty look and feel of the senior portrait. The image on the right was shot using a sweep, but there's still good separation between the backdrop and the floor. Photos by Gary and Pamela Box.

ultimately comes down to personal taste. I'm not here to tell you what is best, only that options exist.

I tend to agree with my client about the sweep—especially when it comes to muslins and many patterned backdrops. However, I think the sweep can be very useful when working with seamless paper. Sometimes you *want* that solid-colored look, and seamless paper is a fantastic option for that. Depending on your subject, the seamless sweep can enhance a portrait—especially when it is chosen to coordinate with your subject's attire (or, in the case of pets, their color).

Permanent Floor

Some studios are outfitted with a wonderland of shooting options and include all kinds of original flooring like aged hardwood or retro tiling. However, I'd be willing to wager that most studios have only one kind of floor—even if it's a great one. There's

nothing wrong with making portraits using that one floor, but soon all your portraits could begin to feel the same. And what happens when your clients don't want their portraits to look like all your other clients' portraits?

My studio floor is concrete. It's plain old gray, which only works for certain portraits. So I tend to put down my own floor for portraits, coordinating it with the backdrop I'm using. If I had the time and ambition, I could paint my floor on a regular basis to keep things changing, but safety and time become issues. If the painted floor is slick after it dries, there's a potential for accidents. No one wants a client falling in their studio. The time issue comes into play two ways. First, I'd need the time to paint the floor. Second, I'd need time to let it dry. This method could get costly, too.

I tend to put down my own floor for portraits, coordinating it with the backdrop I'm using.

Artificial Floor/Floordrop

Artificial flooring, or "floordrops" as some photographers call them, affords you the widest breadth of options. Here are some reasons to use and love artificial flooring:

- You can change it whenever you want, even in the middle of a session
- You can match or complement the backdrop quickly
- You're not locked in to a single floor
- The options for different floors are limited only by your imagination
- You can use a floordrop as a backdrop if you want

A roll-up floor by Denny Manufacturing.

Paneling is a great, inexpensive way to add a new floor to portraits.

Many backdrop manufacturers have added floordrops to their offerings, but they're not all called the same thing. Some other names you might find for floordrops are "roll-up floors" (Denny Manufacturing), "Dura Floors" (Backdrop Outlet), or "prop floors." Whatever you call them, they're essentially the same thing: lightweight, easy-to-transport floors that photograph beautifully and are very realistic looking. Some are printed rugs, some resemble humongous mouse pads (rubber bottom and all), and others are thick polyester fabric or poly-paper (something like a tear-resistant, laminated paper).

Floordrops don't have to come from a backdrop manufacturer. You can find artificial flooring options at your local hardware store, home store, IKEA, or big box department store. A visit to your local fabric store could turn up some interesting options as well. One of my favorite floors is white faux-wood paneling. At less than $15 for a 4x8-foot sheet, it's a great studio flooring option.

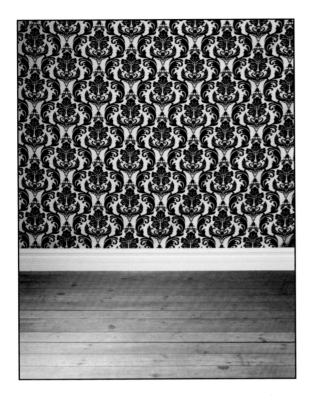

Don't forget that you can use backdrops as floors. Some backdrops can pass as floors better than they can as walls, so feel free to use them that way. Likewise, some floors may make great backdrops—just be careful how you hang them or stand them up.

Also, keep in mind that your floor doesn't necessarily need to look like a floor. You can choose whatever kinds of patterns or prints you want. If you like stripes, knock yourself out. Just make sure the floor material and print/pattern don't clash with your backdrop and subject. Conflicting patterns and craziness can take away from the subject.

The one disadvantage of keeping artificial floors is, of course, storage. As with backdrops, it's easy to get excited and buy tons of flooring options that you'll only use occasionally, so start out with only a few. Think about how many of your portrait sessions will actually use the floor and make your choice based on those usage numbers. When you're planning to purchase flooring options, consider storage in your studio. I store my 4x8-foot paneling sheets flat on the floor, face down. I can walk on them if need be, but they're pushed into the corner of the studio—as far

Changing the floor can change the whole look of the portrait.

out of the way as possible. I don't recommend leaning them on edge against a wall; they have a tendency to warp and bend when stored that way. I discovered that the hard way.

I also use roll-up floors by Denny Manufacturing (the ones that feel like a giant mouse pad), which I keep rolled up when not in use. Other fabrics and materials can be stored similarly to backdrops, either rolled or hanging. Just make sure you take storage into consideration when selecting your floors.

Having the option to change out the flooring whenever you want can more than double your backdrop options, because the presence of a floor can completely change the look and feel of a set. And more options is never a bad thing.

Baseboards

Adding a floor by itself offers the appearance of realism, but going one step farther and adding a baseboard finishes it off.

Adding a baseboard completes the look.

Make sure you take storage into consideration when selecting your floors.

A-clamps at either end of the baseboard allow it to stand up and be moved into position against the backdrop.

Baseboards come in all shapes and sizes, but I find that the larger baseboards work best because they are more recognizable in the photos as baseboards. You can find unfinished or primed baseboards at your local hardware store for a very reasonable price. Pick up some paint or stain to make them your own and you've got a new set prop that makes your wall and floor look like a finished room.

The easiest way to position baseboards by adding A-clamps (also available at local hardware stores) at either end so the baseboard stands by itself. Once it's standing, push it back as close as possible to the backdrop. Don't worry if the backdrop doesn't exactly fit snuggly against it, though; chances are you won't be able to tell in the photo.

Some prop manufacturers have started producing baseboards that are specifically designed to work with their backdrops. They might feature hooks or other means of connection to keep the backdrop flush against the baseboard. But, as I mentioned, you may not need the backdrop to be flush with the baseboard—especially since the lighting comes from above. If you really want it to be flush, you can easily loop a few pieces of gaffer's tape and stick it on. That will work perfectly for a session.

Hybrid Wall and Floor in One

A new trend hitting the backdrop market is an all-in-one solution with a printed backdrop, baseboard, and floor all on the same piece of material. One of example of this is the Twin Drop (from Simply Canvas), which you can customize by choosing the color of the wall, baseboard, and floor sections from their library. Depending on the manufacturer, the material for these all-in-one

I find that the larger baseboards work best because they are more recognizable.

backdrops is likely 100 percent polyester. Storage of an all-in-one is as simple as with any other normal fabric backdrop.

All-in-one backdrops set up just like any other fabric backdrop, as well—only you need to make sure the printed baseboard is even with the ground. Also, because of the straight line, you'll need to pay special attention to make sure the backdrop is horizontally level. If it's not, you're sure to see it in the portraits.

This type of backdrop may not be the best solution for all photographers, but it's a great option for location shooters working in less-than-attractive (or unknown) settings. With these units, you can basically take an entire room with you—so you're prepared for anything. And traveling with one is a breeze. Another advantage is that you always have your three elements together. A disadvantage, however, is the inability to change out any of the elements. You'll always be tied to the same backdrop/floor combination.

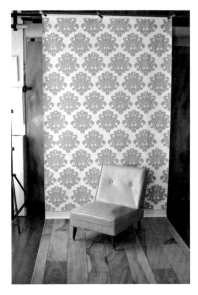

This type of backdrop includes the wall, baseboard, and floor all in one. Photo by Visualizations Photography.

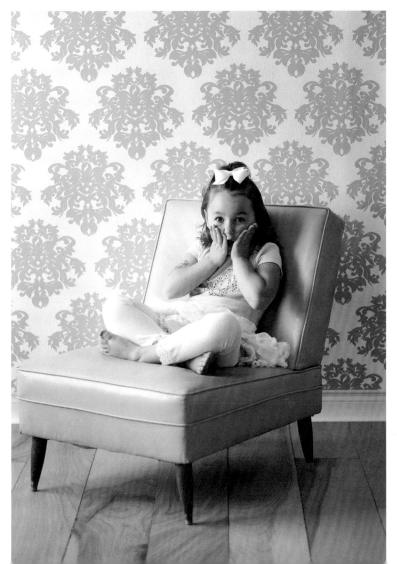

5. Producing a Pure White Background

Portraits on a pure white background are useful for many applications. From headshots on a web site to a printed magazine ad, the versatility of having your subject on a 100 percent white background is indisputable. But knowing how to do it properly is the key to making it look right. I'm not talking about Photoshop here—I'm talking about getting the image right in-camera.

You can achieve a pure white background in the studio several ways. I'll look at a few of them here, but these are, by no means, the only ways to do it. I simply believe they're the most effective. Plus, they don't require a lot of cleanup or masking in Photoshop afterward.

The biggest challenge of shooting on a white background—and making it 100 percent pure white—is the lighting. (By "100 percent pure white," I mean zero color data in the whites or RGB values of 255/255/255.) You simply can't light the background with the same main and fill lights used on your subject and expect to get both a pure white background *and* a well-exposed subject. In order to achieve a pure white background with a properly exposed subject in front of it, you must light them both separately no matter which method you use. That's the key to making this work.

The beauty of shooting your subject on pure white is being able to extend the background in Photoshop, either vertically or horizontally, as far you like. Just add headlines and copy and you've got an instant band poster, invitation, or postcard.

The versatility of having your subject on a 100 percent white background is indisputable.

The pure white background opens up loads of opportunities to get creative with your portrait and to use it in a multitude of applications.

Let's take a look at two of the more common ways to achieve this look.

White Seamless Paper

My preferred method of achieving a pure white background is using white seamless paper as the backdrop. Not only is this approach great for headshots, but it also makes full-length

Portraits on a pure white background keep the emphasis on the subject.

portraits a snap because you can pull out as much paper as you need to accommodate your subject. Here's what you'll need:

1. A roll of white seamless paper mounted on a background stand.
2. At least three strobes on stands with modifiers (softboxes or umbrellas).
3. A large shooting space—ideally, about 20 feet from the backdrop to the camera.

First, set up the white seamless with enough paper pulled out to accommodate your subject. If you're planning on shooting full-length portraits be sure to pull enough paper to allow it to run a little past where your subject will be standing so the white starts in the foreground.

Next, set up the background lights—one strobe on either side of the seamless pointing at the background. Place them at least 5 feet away from the background. You can use umbrellas or softboxes on the strobes, just make sure they're pointing at the seamless, so the majority of the light hits the paper. The goal is to minimize any light spill and keep it off the subject.

First, set up the white seamless with enough paper pulled out to accommodate your subject.

A pure white setup using umbrellas and white seamless paper.

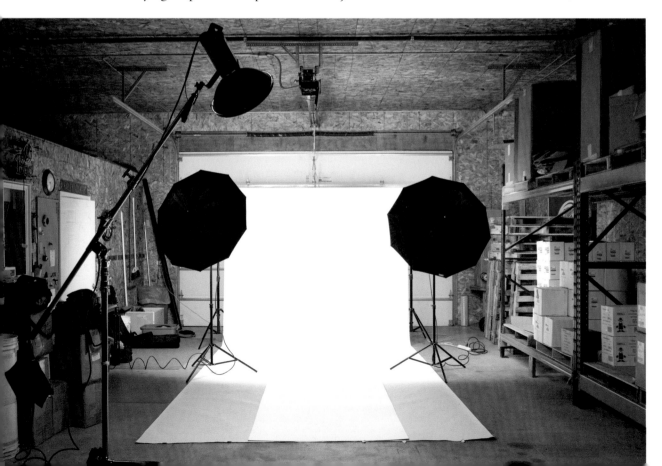

The model is being lit by a beauty dish while the umbrellas light only the seamless backdrop.

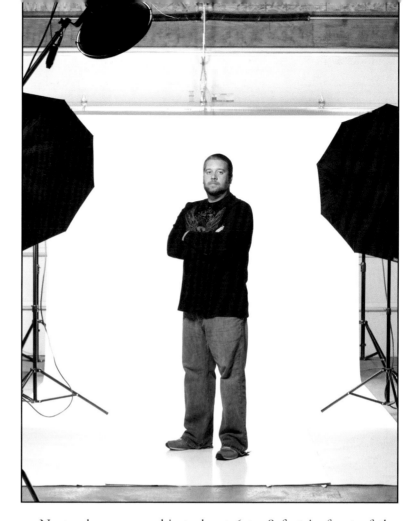

Once everything is in place, set and meter your lights so the backdrop is overexposed.

Next, place your subject about 6 to 8 feet in front of the seamless, far enough away from the background lights to keep them out of range of any spill light. Finally, set up your main light as you normally would, using the modifier of your choice. If you have more strobes available, you can add a fill light or position a reflector to achieve a pleasing light pattern on your subject.

Once everything is in place, set and meter your lights so the backdrop is overexposed, making it ¾ to 1 stop brighter than your main light. That ¾ to 1 stop difference should allow the seamless background to completely blow out, eliminating all detail. With the setup in place, take a test shot and check the histogram on the back of your camera to ensure the backdrop shows highlight clipping.

Shoot a few more test frames and make sure your subject isn't being hit by light wrapping around from the background lights.

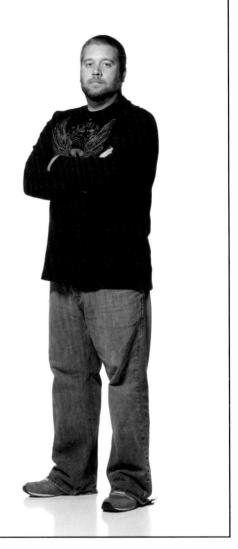

If so, move them farther away from the backdrop and reposition your main light(s). When you're happy with the lighting on your subject and the background is blown out, you're ready to shoot your session. If you're shooting headshots, make sure to get close to your subject and allow them to fill the frame as necessary—because you can always go back later and add more white around them. Like cropping anything else, it's better to start larger and reduce as opposed to starting small and having to enlarge.

A properly photographed subject on white can easily be placed on any background.

If done correctly—so there's very little, if any, light wrap coming around your subject—you can very easily mask your subject out of the white background using the extraction tools in Adobe Photoshop. Then you can place your subject on any background you want!

Softbox Backdrop

Another method for achieving a pure white background is to use a softbox, placed directly behind the subject, as the backdrop. This method works particularly well for fashion or glamour portraits because the light from the softbox typically wraps softly around the subject. Depending on how strong you make it, the light-wrap effect allows you to get more creative with your subject and lighting to produce a non-traditional look. It only works for headshots, not full length portraits—just because of the angle of the softbox and the size constraints. If you don't want light wrap, use the method described in the previous section. Here's what you'll need:

1. For the background light, one strobe and light stand with a fairly large softbox (at least 48 inches).
2. For the main light, one strobe and stand with your choice of modifier.

Start by setting up the background light. Attach the large softbox in vertical orientation, then tip it back at a 45 degree angle upward. Place your subject about 1 foot in front of it. It may not make much sense to have a light source directly behind your subject, but you don't have to worry about lens flare since the softbox is angled up. Next, light your subject as you normally

This method works particularly well for fashion or glamour portraits.

Setup shot of a pure white background using a softbox.

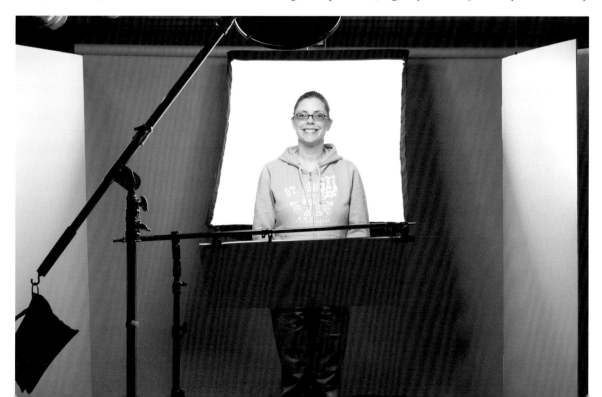

ABOVE—The softbox angle is necessary to avoid light spilling into the lens and creating flare.

LEFT—The model was isolated on pure white using a 48-inch softbox as the background at f/8. The main light was at f/5.6.

would using a main light (and, if desired, any configuration of fill light or reflector).

Once all your lights are in position, meter them as you would for the seamless background mentioned above, starting with the background light about 1 stop brighter than the main. You may have to adjust the background light down to only ½ stop brighter than the main to minimize the light wrapping around your subject. Watch for this wraparound effect while you're shooting and adjust as necessary. Remember, the goal is a pure white, zero-detail background—so if you're still getting too much light wrap and the background isn't blowing out, try moving the background softbox further behind your subject. You'll probably have to increase the power of that light as you do so, but it should help reduce the wrap.

Other Methods

As I said earlier, there are many other ways to achieve a pure white background, but I think these are the most effective and cleanest. Plus, they require very little, if any, postproduction work aside from possibly extending the background. A related technique, using a cyclorama wall, is presented in the next chapter.

6. Cyclorama Wall

Another way to achieve a pure white background is by using a cyclorama wall (also called a "cyc wall" or "infinity cove"). This is a permanent studio background with a rigidly constructed sweep. Often spanning two walls, it sweeps down across where the wall meets the floor and also spans the vertical corner where the two walls meet. Because the resulting wall-to-wall and wall-to-floor transitions are concave, instead of 90 degree angles, the shadows in these areas are diminished. The cyc wall is built against existing studio walls and is usually made of wood and drywall. A cyc wall is permanent and costly, but very effective for white isolations.

This is a permanent studio background with a rigidly constructed sweep.

Benefits

Cyc walls are ideal if you photograph large groups of people or large objects (cars, motorcycles, furniture, etc.), or if you need to isolate large subjects. With such a huge background, as long

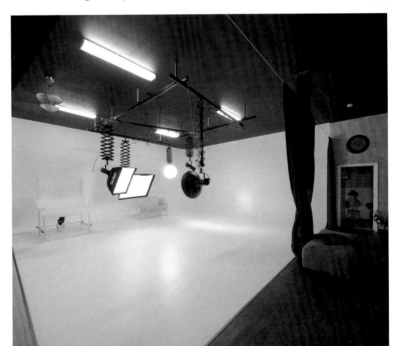

A cyclorama wall. Photo by Stan Foxworthy.

as your lighting is right, you can move around your subject much more freely—without having to worry about keeping the background directly behind them, as would be the case with a roll of seamless. When you focus more of your attention on your composition and the feel of the shoot instead of constantly worrying about running out of background, your work shows it.

There are other benefits, too. One is your background not tearing or creasing like a roll of seamless paper when working with children or groups. Models' high heels (or dogs' claws) punching holes in your seamless will no longer be an issue, either.

Cyc walls also keep things simple in postprocessing. While there's always a bit of cleanup work that needs to be done, shooting on a cyc wall reduces the need for extensive retouching. Remove a few footprints, heal a few dots, and you're done.

Lighting

Lighting for pure white on a cyc wall is exactly the same as for the seamless paper method—but on a much larger scale. You're

> Models' high heels (or dogs' claws) punching holes in your seamless will no longer be an issue.

Musical performers photographed against a white cyc wall. Photo by Stan Foxworthy.

A cyc wall gelled for color. Photo by Stan Foxworthy.

Just because it's white doesn't mean you're always going to want to blow out the background.

still lighting the background and subject independently of one another, but because your subject may be larger, you may need more lighting on the background to fully blow it out. Likewise, you may need more or larger light sources for the main and fill lights on your subject.

However, just because it's white doesn't mean you're always going to want to blow out the background. Just as with white seamless paper, you can make the cyc wall appear gray by limiting the light that hits it. Or, you can get creative with gels and add a touch of color to the wall for something other than white. Using an overhead light with a gel pointed at the cyc wall creates a nice gradient as it gets to the floor.

Maintenance

Maintaining an infinity cove requires a good bit of work. It must remain clean and white in order to be effective, so regular painting is recommended—and not with just any paint. Flat

white latex paint is fine for the walls (it fights glare and minimizes imperfections), but you can't use it on the floor. With flat latex paint, footprints and scuff marks will show up faster than lint on a black shirt. Instead, the floor requires something more durable, like a two-part epoxy-based floor paint or water-based modified acrylic enamel. Both will resist scuffs and marks longer, and they are fairly easy to clean.

An additional concern is the fact that buildings shift and settle. Just like the drywall in your house, an infinity cove can, over time, show minor blemishes like cracks or nail pops. This is normal and repairable. Since you'll likely be painting it on a fairly regular schedule, these repairs just become part of the routine.

Is It Right for You?

A cyc wall has many uses—but before deciding to add one to your studio, first ask yourself if you can achieve the same results using a roll of seamless. If you can, you'll save yourself a few thousand dollars. If you only need an oversized white seamless backdrop like a cyc wall once in a while for a certain client or job, you might be better off renting a studio space that has one. That way you're not investing space, time, and money in something you'll use infrequently.

A bridal portrait against a cyc wall. Photo by Stan Foxworthy.

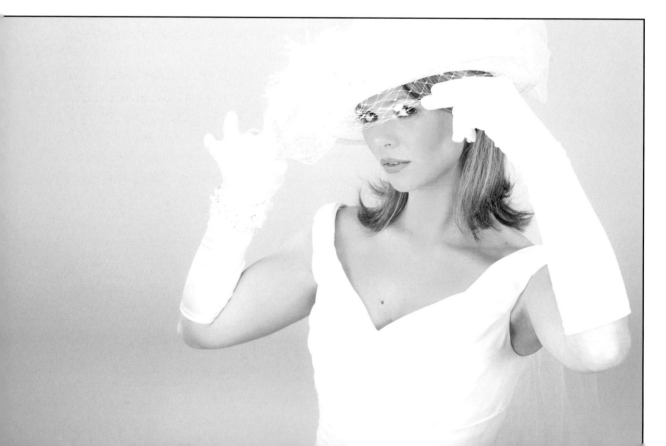

7. Producing a Pure Black Background

A pure black background works so well because it directs all the attention to the subject.

Just as versatile as a pure white background is a pure black background. Well, okay—maybe it's not *quite* as versatile, but it's still very useful for creative options and isolations. A pure black background works so well because it directs all the attention to the subject by removing any competing elements. The viewer has no choice but to look at the subject because that's all there is. The same goes for pure white, but pure black tends to suck the viewer in even more because the subject is framed in black and viewers typically look at the lightest spot first. In the case of a pure black background, that means they're looking at the subject first.

A pure black background is great for creative and dramatic lighting. Whether your subject is a newborn swaddled in all black or a CEO in a headshot, a pure black background is a great way to make sure they're the focus of the portrait.

Just like a pure white background, there are several ways to achieve pure black. I'll address the most common, accurate, and easiest here. To start, three things determine the success of a pure black background:

1. The backdrop color.
2. The distance between your subject and backdrop.
3. The main light and flagging.

Backdrop Color

Getting a black background doesn't always mean you need a black backdrop. The distance between your subject (and main light)

and your background will determine how black your backdrop needs to be. If the distance is over 20 feet, you could use a white seamless and still achieve pure black so long as no light spills onto the white and you're using a fast enough shutter speed to drop out everything that the light doesn't reach.

The easiest way to achieve a black background, of course, is to use a black backdrop so you don't have to place it 20 feet behind the subject. You could use a black bed sheet, black seamless paper, black velvet, or black curtains. The good news about this backdrop is that wrinkles won't make a bit of difference. The goal is an RGB value of 0/0/0—or 100 percent shadow clipping.

Distance

For portraits with a black background, the distance between your subject and the backdrop needs to be more substantial than with a white background. You can't place your subject 3 feet in front of a black backdrop and expect it to zero out to pure black. Your main light will spill onto the backdrop and show highlights on the black. So place your subject as far from the background as you

BELOW AND FACING PAGE—Pure black backgrounds make the subject—or subjects—the clear focus of the portrait.

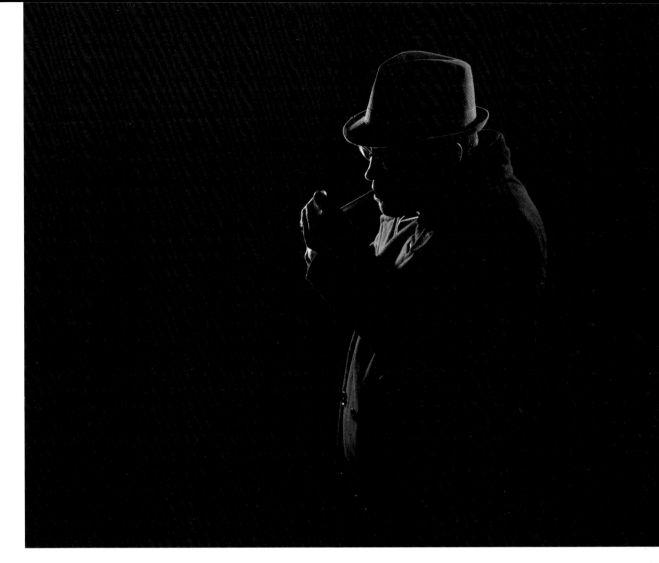

can. Eight feet is a good starting point. The greater the distance, the easier it is to make the background pure black.

Lighting and Flagging

Lighting for a pure black background is much simpler than for white. For black, you just want to keep light off the background; for white, you need to make sure plenty of light floods it.

The key to lighting your subject against a black background is to light *only* the subject. You don't want any light hitting the backdrop; that light will make the backdrop record as a shade of gray instead of pure black. One way to do this is by flagging the main light so it can't spill onto the background (be sure to use black flags). Even if you're using a hair light or backlight, you still

Lighting for a pure black background is much simpler than for white.

need to keep all light spill off the backdrop, so use as many flags as you need.

Because the backdrop will be pure black, you can move your flags as close to the subject as you want; if they show up in the photo, you can remove them in postprocessing by filling those areas with black. The main thing you need to pay attention to is that all the space immediately surrounding your subject is pure black. If the distance between your subject and backdrop is great enough, flags won't be necessary.

With your setup in place, meter your main light at an aperture you're comfortable with and photograph your subject as usual. Then, check to see that the shadows are clipped all around your subject.

Postproduction Cropping

The beauty of pure white or pure black backgrounds is the ability to extend them very easily in post-production. As long as the immediate area around your subject is pure black or pure white,

If the distance between your subject and backdrop is great enough, flags won't be necessary.

In this setup the subject is about 10 feet in front of the background. He is lighted by a beauty dish while a softbox provides separation from behind.

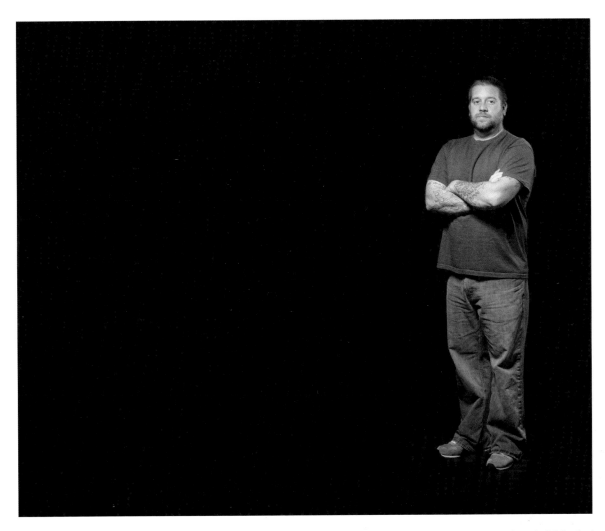

Some simple cropping in Photoshop allows you to fill as much of an image with black as you'd like.

you can then paint or fill the rest of the image with solid black/white and it will match beautifully. This gives the illusion that your subject was in a much larger space—and it also makes room for text if you're doing an announcement, invitation, or poster. This is a trick used in all kinds of advertising, but it works well with portraits as well.

8. Digital Backdrops and Composites

Once in a while you'll come across a perfect backdrop, but you won't be shooting at the moment or it will be in a logistically impossible location. For instance, you'll come across a cute storefront and alley in a plaza on the outskirts of Ladenburg—a place you know would be the perfect setting for one of your subjects in the United States. Of course, it would be nice to fly back to Germany for the shoot, but that's neither likely nor realistic for most of us.

The next best thing is to take a photo of that storefront and alley, then superimpose your subject onto that scene to create a composite. A composite is an image created using elements

A portrait created with a digital background. Photo courtesy of FJ Westcott.

A model photographed against a green chromakey backdrop. Photo courtesy FJ Westcott.

Some kits come with a reversible green/blue portable chromakey background. Photo courtesy FJ Westcott.

from multiple photos all put together in one layered file. Think of it as cutting out your subject and pasting them into another photo. While some photographers create very complicated and detailed composites, here we're talking about simple two-layer composites—a background and a subject.

Chromakey Backdrops

The key to believable composites is clean, accurate backdrop removal. That's where green-screens (or "chromakey" backdrops) come in. It's been discovered that green chromakey backdrops work best with digital cameras because the green channel contains the least amount of noise, thereby allowing a cleaner masking and removal process. Green is also unlike any normal human skin tones. Any solid-color background can be used, even white as discussed in chapter 5, but green definitely has its advantages.

Green chromakey backdrops also require less light than blue or other colors—but bright, even lighting is still required to create good contrast between the subject and the background. This is important for good masking and easy separation in postproduction.

Green screen kits that include lighting, a green screen, masking software, and educational DVDs are becoming very popular, and are available at most major photographic retailers. An Internet search will provide you with plenty of options. Be smart about these kits, though. They often sound too good to be true—you get lights, light stands, the chromakey backdrop, and a DVD full of digital backdrops in one affordable package . . . but a very low price should send up a caution flag. Double check what kind of lights are included in the kit. If you don't do your homework, you may be investing in glorified hardware-store clamp lights with overheating issues.

Lighting the Subject

The reason to shoot portraits against a chromakey backdrop is, of course, so that you can use some other digital image as your background. Got some great scenic images from your latest vacation to Europe? Great. You can place your subject as if she

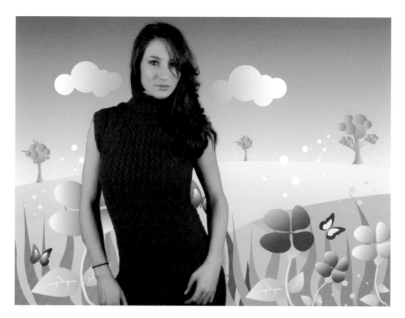

Backdrops of all styles can be added digitally with a chromakey system. Photos courtesy FJ Westcott.

were there. Have you created a *Star Wars*–inspired space scene in Photoshop? Perfect. Place your subject right in the scene (just make sure their outfit matches).

Because your final composites will involve these secondary images, it's important to plan out your lighting carefully. In fact, the most challenging part about digitally "placing" subjects in front of random backdrops is matching the lighting and shadow patterns on your subject with the lighting and shadows in the background image. I suggest adding a little backlighting on your

I suggest adding a little backlighting on your subject to help keep the placement realistic.

subject to help keep the placement realistic, no matter the scene—but you still need to pay attention to shadows and angles of the light sources in your background images. If the light source in the background image comes from the left and you light your subject from the right, the two images won't look right. Adding in a slight rim light from the left will help make it more realistic, because it may appear that the background light (from the left) is spilling over your subject's left side. Either way, to achieve realistic composites using background removal techniques, it's imperative that your shadows and lighting work together.

For most commercial portrait studios, traditional and flat lighting situations will be just fine for use with the majority of digital backdrops—especially those purchased from a digital backdrop manufacturer.

Chromakey Removal

Providing detailed instructions on chromakey work-flow strategies would be a book in and of itself. Basically, though, accurately removing the chromakey background (the green area around the subject) requires an application like Adobe Photoshop; Lightroom or Aperture won't work, because you'll be removing and masking pixels, not just changing how the image is viewed. Many chromakey backdrop manufacturers also offer their own software to assist in dropping out the green background and adding in another digital scene. Just make sure that whatever software you're using has the ability to refine the edges of a selection and also to decontaminate colored spill light.

Using masking applications and perfecting extractions takes time and patience. If you're considering using digital backgrounds, don't get discouraged if you don't experience exceptional results right away. Unless you're very comfortable with masking to begin with, expect to invest some time learning how to make this process work smoothly.

Digital Backdrops

Once you've extracted the subject (isolated it from the green background) you can add your digital backdrop. Digital backdrops

Using masking applications and perfecting extractions takes time and patience.

Masking tools, like onOne Software's Perfect Mask, make it easy to replace backgrounds.

An example of a digital backdrop image. Photo courtesy FJ Westcott.

are simply image files—JPGs, TIFs, PSDs, etc. Don't get hung up on the word "backdrops." These images could be photos of physical backdrops, photographs of sets, or scenic views. Your digital background could even be a custom image you created in Photoshop from several other images. Digital backdrops can be whatever you want. You can have a digital backdrop of your cat if you want—it's just an image file. That's all.

If you don't have your own digital backgrounds, you'll have no problem sourcing some. There are no shortage of retailers offering them for sale or online download. (Happily, most of the digital backgrounds available for purchase are evenly lit—which makes it easier on you when it comes to lighting your subject.)

Many background manufacturers are making digital backdrops a part of their normal offering. Plus, they typically have a wider library of choices than you'll be able to build yourself. They even include backgrounds of real portrait sets from other photographers—a great option if you don't want to purchase seasonal backdrops that only get used once a year.

You can even buy software to create your own digital backgrounds that replicate fabric backdrops, drape shadows and all. Backdrop Designer by Digital Anarchy is one such product. (They also make a chromakey background removal application

You can have a digital backdrop of your cat if you want—it's just an image file.

A big argument for
using digital backgrounds
in your studio workflow
is the cost savings.

called Primatte Chromakey.) The software is a Photoshop plug-in based around ready-made patterns, but you can also make your own. The backgrounds mimic realistic backdrops by including texture layers to add believable folds, draping, and other features.

Are Digital Backgrounds Right for You?

A big argument for using digital backgrounds in your studio workflow is the cost savings. For the price of two or three professional fabric backdrops, you can have hundreds of digital backgrounds on DVD. Also, storing them is a breeze compared to physical backdrops; all you need is a DVD or a hard drive. (No washing and no steaming of wrinkles required, either!)

Of course, there's also a trade-off: you'll be spending a lot more time in postproduction, removing backgrounds and masking subjects. If you're like most photographers, you're really only making money when you're behind the camera—not when you're behind the computer. So keep in mind the possibility of lost revenue if you're considering using digital backgrounds.

Adding digital backdrops offers unlimited creative potential—but also increases your postproduction time. Photo courtesy FJ Westcott.

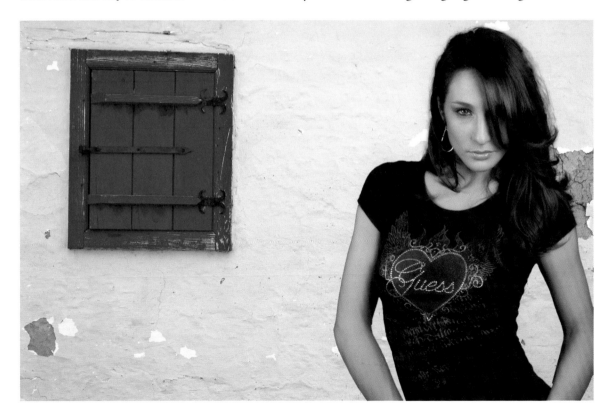

9. Portable Backdrops

Sometimes all you need is a simple headshot setup to take on location. Maybe you're shooting for a corporate directory, creating images to accompany employee biographies on a website, or even making quick headshots for a theater company in a cramped backstage room. Whatever it is, there's something to be said for a professional backdrop that you can set up and tear down quickly—and one that fits in tight spaces. That's exactly what I'm talking about here: portable backdrops that are designed specifically for easy transport and quick setup.

Of course, any backdrop setup could be considered "portable" if you don't mind hauling gear (or if you have assistants to do it). But it's overkill to bring a 20x12-foot muslin and heavy-duty backdrop stand for headshots or single-person, directory-style portraits. There *are* times you need portability on a large scale (for those times I'd suggest using lightweight, wrinkle-resistant polyester backgrounds), but in this chapter, I'm focusing on smaller-scale portable options—backdrops small enough to fit in a shoulder bag.

A pop-out style portable backdrop. Photo courtesy Calumet Photographic.

About Portable Backdrops

Portable backdrops come in all shapes and sizes. Some fold up like a reflector into a compact carrying size, others are a muslin that's stretched with poles. And just like their full-sized counterparts, they come in all different patterns, from the standard hand-painted masters' muslins to solids and even printed scenic images. The material for portables is generally synthetic, so they resist

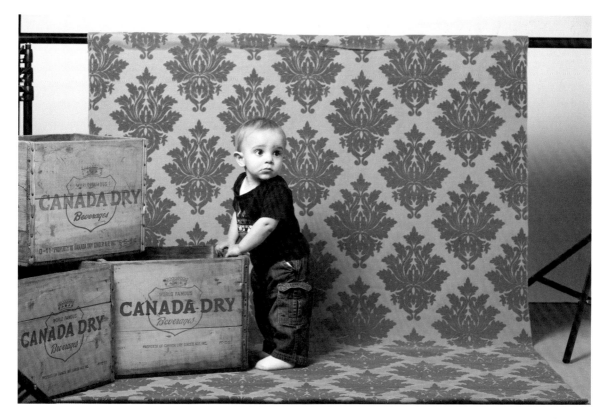

This 5x7-foot backdrop by Drop It Modern is a standard backdrop, but it's small enough to pack and go anywhere.

wrinkles and are easily cleaned. They're usually physically smaller, as well—somewhere around 4x6- to 8x8-feet.

Benefits

There are some important benefits to using smaller-scale, portable backdrops. This list is by no means exhaustive, but it's enough to give you some understanding of when and why you might want to use a smaller setup.

1. They're great for taking on location and shooting in tight situations. If you've ever had to do corporate headshots in the back of someone's office, you know what I'm talking about. You'll be lucky if you get a 10x10-foot room to work in.
2. They're usually less expensive than full-size muslins or other backdrops. Less material means less cost—and less bulk. The money you save can be spent on other portable backdrops.

3. Storage is typically easier because they're meant to travel. They're made with portability in mind, so by their very nature they pack up small.

4. They're easy to set up—often with only one stand. Again, this makes them perfect for the cramped dressing-room or corporate-office setting.

5. They're good for smaller studios. If your studio resembles a cramped dressing room or corporate office, these units may solve your space issues.

6. Several manufacturers make double-sided models, so you have at least two options with each unit. Some are black on one side, white on the other, or white and gray. Several manufacturers even offer two different patterns, one on either side.

Most photographers using portable backdrops like these are doing headshots or single-person portraits. Directory portraits or similar business portraits are a breeze with such a small setup. Depending on the portable backdrop you buy, most will accommodate up to two comfortably. Some portables, though, are large enough to accommodate groups of up to five or six people—but that's on the large end.

Collapsible Backdrops

Plenty of manufacturers make collapsible backdrops that fold up like a standard reflector. They vary in size—4x6- to 8x8-foot sizes are fairly standard—and some include an extended section that can unfold to create a sweep. Searching the web for "collapsible backdrops" or "portable backdrops" will turn up more results than you'll consider clicking. One of the biggest benefits of collapsibles with a frame is that wrinkles are rarely an issue; once the background's frame is expanded, the material is stretched taut and smooth around it—just as with a reflector.

Don't Forget DIY

Don't rule out the do-it-yourself option of purchasing material from a fabric store. The width of most fabrics (45 to 60 inches)

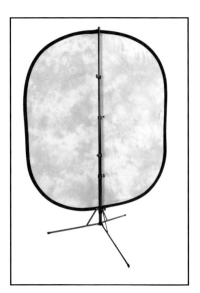

A collapsible backdrop. Photo courtesy Calumet Photographic.

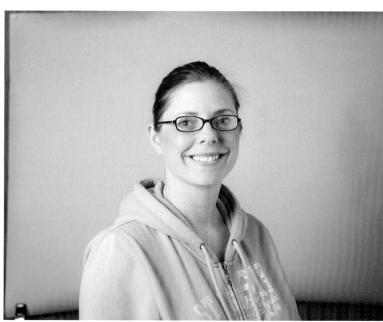

A piece of paper is affixed to a wall (top left) and the model is lit against it (top right). On the right is the same photo cropped to a vertical headshot to show the viability of this setup.

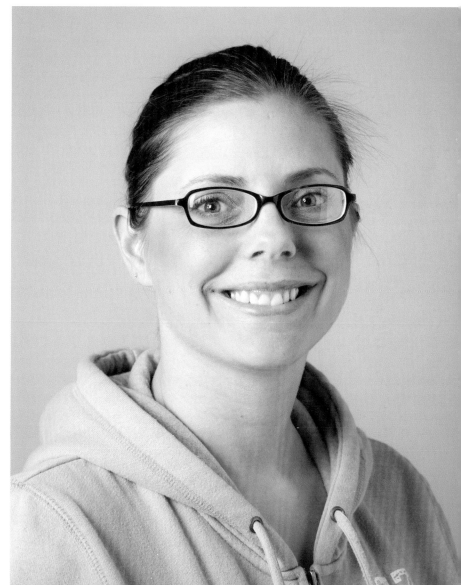

will be just right for single-person portraits. Just make sure the fabric you choose photographs well and is professional enough for your purposes. As mentioned earlier in the book, heavier weaves like canvas or outdoor fabrics are typically thicker so they resist wrinkles and creases better than standard cotton fabrics.

You can affix one end of the material to a thick dowel and roll it up. This makes for easy storage and helps fight wrinkles, too. Drill a hole in the exact center of the rod so you can quickly set it up on a light stand. With the hole exactly in the center, your backdrop will perfectly balance on the stand.

One Last Option

One last option for ultra-portability is a single sheet of seamless paper taped to the wall (see illustrations on previous page). No kidding. This only works if you *know* that's all you'll need, of course. Minimalist? Absolutely. Professional? Maybe not—but what determines whether something is "professional"? Is it the final product or the process used to get there? Showing up with just a sheet of seamless tucked under your arm and a roll of gaffer's tape may not give the professional appearance your clients expect—so if you go this route, your lights and camera kit better make you look more professional than your backdrop. (Especially when your client receives your bill!)

The canvas backdrop in this portrait lends the image a professional look and feel.

Make sure the fabric you choose photographs well and is professional enough for your purposes.

Portable Backdrops to Check Out

Denny Manufacturing Twistflex
Lastolite Collapsible Background
Calumet On-Site
Backdrop Outlet Flex Out
Wescott Collapsible Background

10. Lighting the Backdrop

Just as you light your subjects in a way that's unique to your visual voice and style, you also need to pay careful attention to how you light your backdrops. As with so many things in photography, consistency and repeatability is the goal, so once you figure out a lighting pattern that works for your main bread-and-butter shooting, stick with it. That becomes your voice, the reason clients come to you. Of course, there are times to experiment and attempt creative alternatives, but you should never feel like every client is an experiment. In other words, you need to know how to light the backgrounds you have and how to do it in your own studio space. Whether you're shooting in

The light skimming across the tufted velvet backdrop reveals its texture. Photo by Gary and Pamela Box.

a basement studio with 8-foot ceilings or a 25,000 square-foot mega-studio, you need to know how to work in your space with your gear.

Use a Meter

Whether you're using strobes or continuous lights, I suggest using a light meter to start. After you get very confident in your setup you can probably eyeball it or feel comfortable enough with the settings on your lights that you know when they're right. Until then, a meter is a great tool for precision lighting.

Light the Subject and Backdrop Independently

I know plenty of photographers who use their main light to light the subject and background simultaneously. They just count on the spill from their main light to offer enough illumination for both. While that works, I prefer to light the subject and background independently. By doing so, I can make sure I achieve appropriate contrast and separation between the two. If you're depending on your main light to also act as the background light, chances are the contrast between the two is going to be muted. And if you're using a dark backdrop to begin with, that can be a real problem. The results of this approach often feel flat and lifeless.

As a general guideline, I typically start off with my background 1 stop darker than my subject. So if the key light on my subject is f/5.6, I'll want to expose my background at f/8. This isn't a do-or-die rule, it's a starting point. Sometimes I'll go darker, sometimes brighter, but that 1-stop difference is just my starting place to begin making creative decisions based on the mood of the portrait and the expectations of my subject.

Light Positioning

Professional portrait photographers place background lights in all different positions on a set, but two very common positions for lighting a backdrops are from the side and from directly behind the subject. In both cases, the lights are pointing at the backdrop.

Lighting the backdrop from the side can be done using a standard light stand, strobe, and modifier. Lighting the backdrop

I typically start off with my background 1 stop darker than my subject.

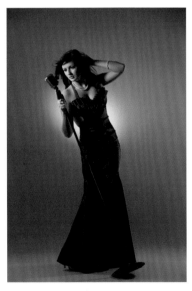

Here, the light on the backdrop was directly behind the subject. Photo by Gary and Pamela Box.

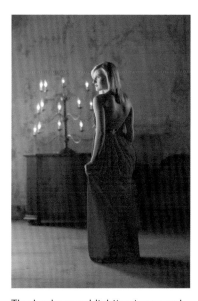

The background lighting increased the sense of dimension in these dramatic portraits. Photos by Gary and Pamela Box.

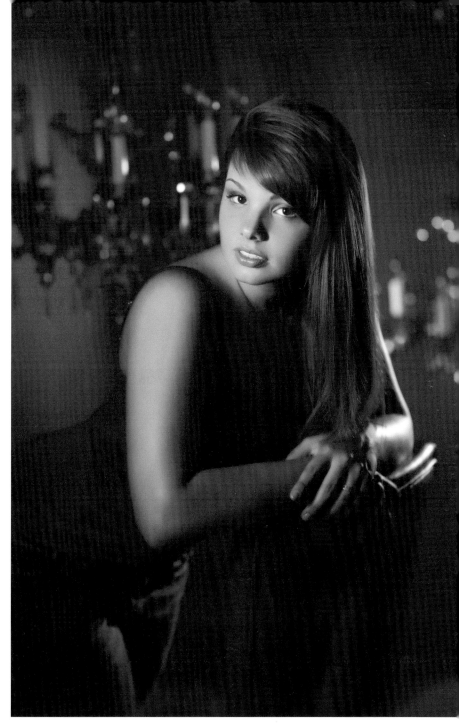

from behind the subject, however, requires that the light and modifier are low enough, and small enough, to be hidden behind the subject. Background light stands are commonly used for this purpose. They're small stands specifically meant to keep strobes low and hidden behind subjects.

Light Modifiers

Choosing the right modifier for a background light is a matter of personal and creative preference. A few of the more popular background light modifiers are shown in the following image sequence. Image 1 shows the background being lit by the main light only. Image 2 shows a background reflector on the light. In image 3, this is placed on a light stand that is low to the ground, behind the subject and out of camera view. Image 4 shows a grid spot; as seen in image 5, this directs a soft-edged circle of light onto the background. You can control its width with different sized grids. In contrast, a snoot (image 6) makes a fairly hard-edged circle of light on the backdrop depending on how far away it is placed (image 7). It can get distorted because of the angle if it's not placed directly behind the subject. Image 8 shows a strip box (a type of small softbox) which, as seen in image 9, spreads light fairly evenly with very little light spill onto the subject. Strip boxes allow for more control of the light on the background than a standard softbox would (compare images 9 and 11). Some photographers use the modifier from the side, others use it from the ground pointing up to create a gradient.

It all comes down to what you have available and what you're trying to achieve. Some photographers despise the look of a hot center that slowly fades to the edges—the sure sign of a grid spot. Others want anything but flat lighting on a backdrop so they'll never use a softbox of any sort for backdrops. Experiment with all kinds of modifiers and options to discover what you like best.

Choosing the right modifier for a background light is a matter of personal and creative preference.

1. Main light only.

2. Background reflector (above).
3. Background reflector in use (right).

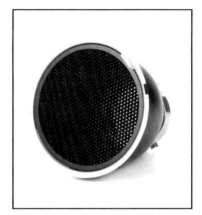

4. Grid spot (above).
5. The soft-edged circle of light produced by a grid spot (right).

6. A snoot (above).
7. The hard-edged circle of light from a snoot (right).

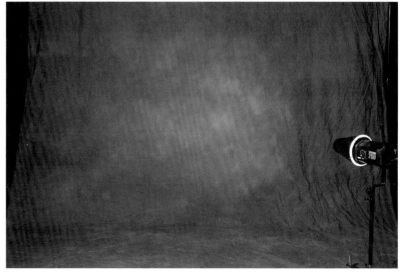

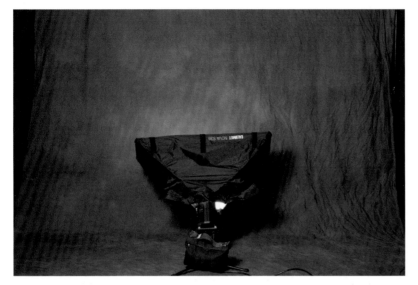

8. A strip box (above).
9. Lighting the backdrop with a strip box (left).

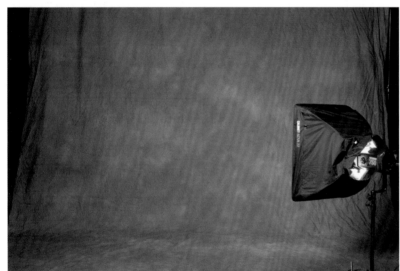

10. A small softbox (above).
11. Lighting the backdrop with a small softbox (left).

11. Setting Up Backdrops

Decide what works best for your shooting style and workflow.

Setting up backdrops is an important aspect of studio shooting that shouldn't be taken lightly. The backdrop setup you use will depend on your studio space, the financial investment you're prepared to make, your personal preference, and the level of portability you require. You could go all out and purchase motorized everything, or go the simple-yet-effective route with a two-stand option. In this chapter, I'll cover some popular setups that you might consider for your own studio. It's up to you to decide what works best for your shooting style and workflow.

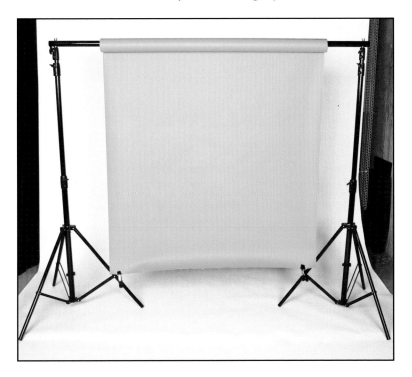

A two-stand setup photographed on a seamless backdrop hanging from an expansion drive system.

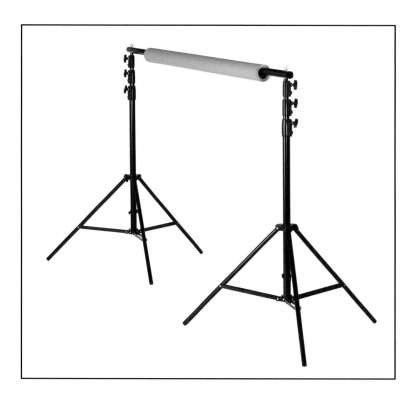

A typical two-stand setup. Photo courtesy Calumet Photographic.

Two-Stand Options

You'll find all kinds of backdrop stands at photographic retailers, but one of the most common is a kit with two stands and an expandable crossbar that goes between them. Some crossbars are similar to extension poles that twist and pull out, others are made up of individual sections that connect together so you can decide the length you need. The crossbar is threaded through the pole pocket on fabric backdrops.

Many manufacturers offer heavy-duty backdrop stands, and I recommend those over standard sets. Here's why: the "heavy-duty" descriptor doesn't only apply to the stands, it also applies to the crossbar. I feel it's always better to go with something more solidly built and weightier when elevating something over clients' heads. Otherwise, while I'm shooting, I can't stop worrying that the flimsy poles behind my subject might come crashing down at any moment—especially when someone steps too close to the sweep or bumps into a stand. Another advantage to the heavy-duty stands is that they are less likely to bend or stress under the weight of heavier backdrops, like ground fabric or 12-foot

Many manufacturers offer heavy-duty backdrop stands, and I recommend those over standard sets.

Two-stand options are great for the studio and for taking on location.

seamless paper rolls. And if you're thinking that you only use lightweight backdrops and always will, you're painting yourself into a corner without room for growth. For the slightly higher price, the heavy-duty options are the best options for versatility and growth.

Two-stand options are great for the studio and for taking on location. Just make sure the set you choose comes with a nice carrying/storage case.

One-Stand Options

Single stand options are typically only useful for smaller backdrops, especially the portables discussed in chapter 9. Many portable backdrops include a hanging loop in the center of the framing, letting you hang them from any light stand. Some portable backdrop manufacturers include a stand with an attached clamp to hold the backdrop in place—centering it is up to you.

Expansion Drive Mounting System

An expansion drive mounting system consists of two brackets that mount to either the ceiling or wall, three sets of expandable cores, which are inserted into the ends of seamless paper rolls or other tubes, three nylon pull chains, and three counterweights for the chains. The seamless roll or backdrop is then mounted by

Brackets for an expansion drive mounting system. Photo courtesy Calumet Photographic.

The Wall Expand System from Denny Manufacturing gives you easy access to three backdrops. Photo courtesy Denny Manufacturing.

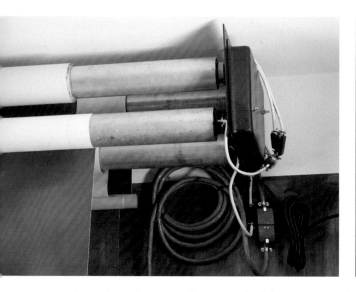
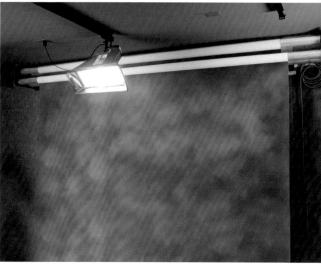

dropping the cores into notched hangers on the brackets. The nylon chain and counterweight go on one end of the cores and complete a pulley mechanism. Pulling the chains raises and lowers the attached backdrops quickly and easily. This system is a huge space saver because it can hold three backdrops or seamless paper rolls at a time without bulky stands.

One of the greatest advantages of having three mounted backdrops is having full-time access to your most-used papers or muslins. Some photographers keep black and white or their most commonly used seamless colors mounted all the time, switching out only one as necessary.

Using the expansion drive system with seamless paper rolls has the added benefit of increasing their useful lifespan. Rolling seamless paper up and down involves much less wear and tear. Plus, the chances of creasing, bending, or wrinkling are much lower than with other mounting methods—especially when rolling the paper back up. That means you can use each section of the paper longer, which ultimately saves you money.

Motorized Roller Mounting System

Similar to an expansion drive mounting system, motorized roller units mount to the ceiling. They make raising and lowering backdrops extremely simple because they are controlled by a switch and run by a small motor. No manual rolling is required

Motorized backdrop systems are a convenient option. Photos courtesy Denny Manufacturing.

Rolling seamless paper up and down involves much less wear and tear.

(unless you go for the hand-crank option). Using this system, the backgrounds are fixed to aluminum tubes, which are then mounted between brackets with mechanical rolling gears on them.

The convenience of motorized roller systems make them an attractive option, but the cost is likely to be prohibitive for many photographers. Starting in the neighborhood of $800 for a single motorized roller, the investment gets serious when you add a couple more. They are typically used for heavier backdrops like canvases but can certainly be used with paper rolls as long as the end is weighted.

Hanging Without a Roller System

One great option for hanging storage without a roller system are Antlers by Drop It Modern. They allow you to hang several backdrops at once in a relatively confined area. Of course, you could find or build a similar DIY solution, but this is ready to mount and works well.

Antlers are good option for hanging storage. Photo courtesy Drop It Modern.

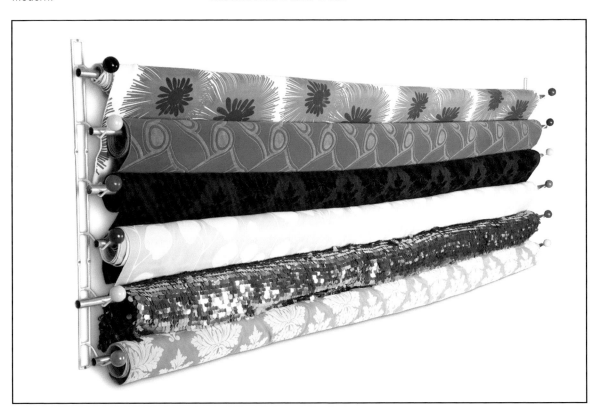

12. How to Choose a Backdrop

Now that we've covered a multitude of materials for backdrops, let's talk about what it all means when purchasing or making your own. Just as you wouldn't buy a new lens without knowing its aperture or focal length, you wouldn't buy a backdrop without first doing a little research about what it's made of, how to care for it, and what's available. Doing your homework on the front end will help you get the most out of your backdrops as far as durability and salability of portraits with the least amount of frustration on the back end. Before purchasing or making any backdrops, consider the following:

Doing your homework on the front end will help you get the most out of your backdrops.

1. Material and wrinkles
2. Storage
3. Maintenance and care
4. Mobility
5. Longevity of the style/pattern
6. Size (what you *need*, not just what you *want*)

Material and Wrinkles

Wrinkles on backdrops are always going to be an issue. Yes, *always*. You either want them or you don't; there is rarely an in between. So you need to decide if you want them or don't. And if you don't, you'll need to plan for how you're going to keep your backdrops wrinkle-free. You could buy 100 percent polyester or ground fabric backgrounds that resist wrinkles, or you can invest in a steamer to combat wrinkles that you know are going to show up in standard fabrics like muslin.

The "Night Life" backdrop by Shooting Gallery Backgrounds.

The wrinkles in this polyester backdrop will shake out without a problem.

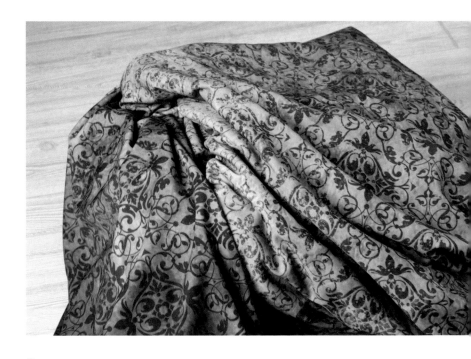

Storage

Wrinkles are often the result of the storage method, so let's talk about the best ways to store your backdrops. If you want wrinkles, or don't care about them, you can make storage really easy by stuffing your backdrops into a large duffle bag or wadding them up and plopping them in a laundry basket. Both methods are sure to yield plenty of wrinkles.

If you don't want wrinkles, there's a little more planning involved. To keep backdrops wrinkle-free, you will need to either hang or roll your backdrops using one of the methods mentioned in the previous chapter. If you don't mind steaming, you could store them folded and steam out the creases each time you want to use them. I'm not a huge fan of steaming, so I'm all for hanging or rolling—that way my backdrops are ready to use when I am, and I can switch them out without a second thought.

I'm not a huge fan of steaming, so I'm all for hanging or rolling.

Maintenance and Care

Depending on the kinds of portraits you specialize in, maintaining and caring for your backdrops may be a significant consideration. For instance, if you specialize in pet portraits, you'll probably need something that is easily cleaned either by hand or by

tossing it in the washing machine. (Although, honestly, if you're specializing in pets, I'd recommend using disposable seamless paper.) Similarly, if you're using your backdrop as a sweep and it sees a lot of foot traffic, make sure it can be washed. You should look for something that is highly durable and capable of taking some abuse.

If your backdrops aren't walked on or dragged around in dirty locations, cleaning them may be of little concern to you. But because you never know what will happen, though, I suggest making sure you are able to clean your backdrops in the event the unexpected occurs—even if you're only able to spot clean it.

Location-based photographers should be concerned with durability in two additional ways. First, setting up and taking down a backdrop outdoors is likely to entail getting it dirty. Second, schlepping backdrops from place to place, then setting up and tearing down, is going to wear on the seams and material. In addition to looking for models that can be cleaned, you'll want to invest in quality backdrops that have reinforced seams, tight stitching, and heavier weaves to withstand constant abuse.

An interesting backdrop pattern (called "Bubbles") from Shooting Gallery Backgrounds.

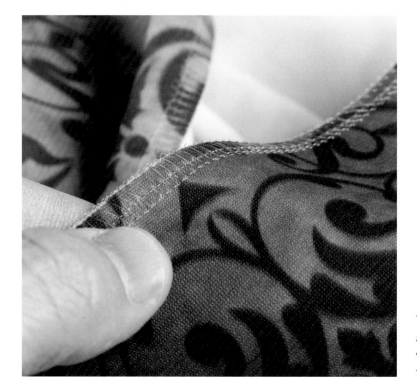

Tight stitching and heavy weaves are desirable in a backdrop that will have to be moved around frequently.

Mobility

If you shoot primarily on location, you'll want to make sure your backdrops travel well and set up quickly. Also, steaming out wrinkles on location isn't fun, so you'll want to consider either wrinkle-free fabric or storing your backdrop on a roll to transport to locations. Size comes into play here, as well. Make sure you have the appropriate size for your intended use to keep the load light. More on size below.

Size

Bigger is not always better when it comes to backdrops. While they come in all different sizes, from little 4x4-foot squares to massive 20x15-foot (and larger) spreads, oversized backdrops can be unwieldy. It's easy to think a larger backdrop offers more versatility—you can use it for everything from large groups down to single headshots—but I can assure you setting up a massive muslin for a single headshot will increase your blood pressure and decrease your patience.

The size of the backdrops you choose will depend on the kind of work you do and how much shooting space you have. Photo by Gary and Pamela Box.

Instead, consider the purpose of the backdrop you're thinking of purchasing. Is it mainly for children's portraits? Then maybe a 5x8-foot model would be sufficient. Is it just for headshots? Maybe a colored roll of seamless might be right. If you know you'll be shooting large corporate groups, that 20x15-foot muslin might be exactly what you need.

As noted, if you do most of your work on location, consider what it will take to transport and set up your backdrop at each new location. Working with the proper size will make setup and tear-down much easier and faster. (See chapter 9 for more info.)

You should also consider how you use backdrops. Will you use it as a sweep so your subjects are standing on it? Or will you use it as a faux wall that stops at the floor? If you're not using it as a sweep, you can certainly save some money by purchasing smaller backdrops.

Choosing a backdrop size should be more about what you *know* you need and less about how you *might* use it in the future.

Print and Patterns, Trends and Fads

Backdrops come in more patterns and designs than you can imagine, but choosing from them comes down to taste. To some degree that's your own taste, but more importantly it's your clients' tastes. Hopefully it's not the only draw, but you may attract some clients simply on the basis of the backdrops you offer. For example, if I were to offer only trendy backdrops that appealed specifically to high school seniors, it's less likely that my business would appeal to family clients who wanted a timeless family portrait to hang on their walls.

Backdrops should also be appropriate to the subject you're photographing. You wouldn't place a CEO of a large corporation on a printed cloudscape backdrop with sun rays shooting through. Likewise, you probably wouldn't photograph a three-year-old at a mahogany office desk with law books behind her, dramatically lit by overhead lighting. Think of it like movie ratings: the rating should match the audience it is intended for.

Few things date a portrait faster than the subject's clothing style, but a close second is a trendy patterned backdrop. At the

A backdrop pattern called "Oilslick" by Shooting Gallery Backgrounds.

The "Flesta" backdrop by Shooting Gallery Backgrounds.

FACING PAGE—This playful background was styled to suit the colors and trim of the girl's dress. Photo by Shannon Sewell.

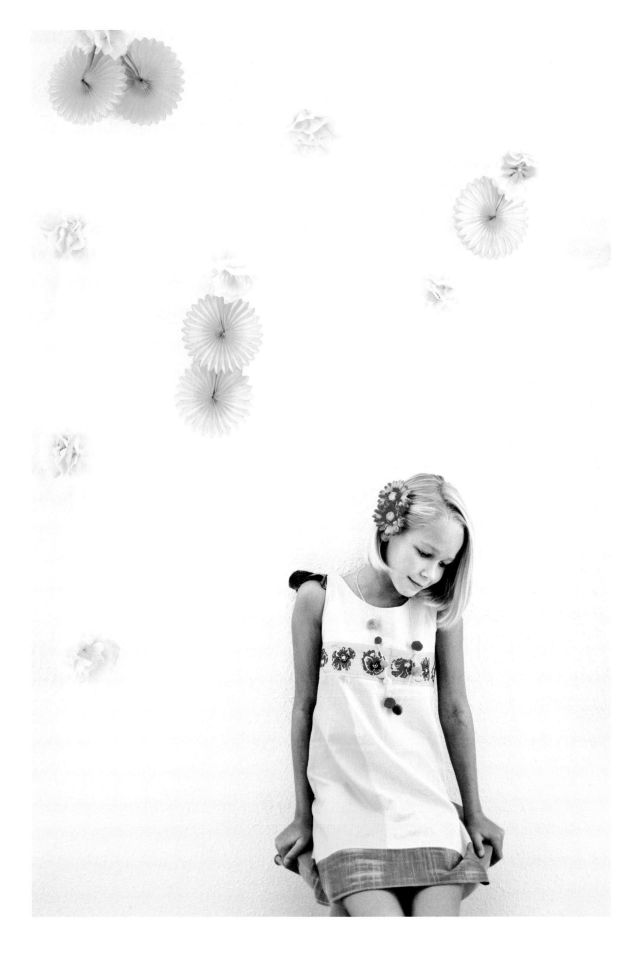

writing of this book, vintage and retro patterns are very popular, as are backdrops with a grunge look. Both are great right now—and I use both in my own studio. However, they may not have the longevity of a master's brown, hand-painted muslin. Such muslins are timeless portrait staples and are likely to remain that way because, in a way, they are a defining foundation of fine portraiture.

The one sure thing about backdrop trends is they are constantly changing. Next year will bring another trend of patterns and textures and innovative printed designs—as sure as the year will start with January. It's just the nature of the backdrop industry. It's up to you to determine which ones you will invest in and what will appeal to your clients. But don't forget to think a little beyond your normal vanilla selections—offering a new flavor just might help you attract new clients you'd have missed otherwise.

Before buying into the latest trend or printed fad, consider the life expectancy of the backdrop. Will it still work for your clients

The one sure thing about backdrop trends is they are constantly changing.

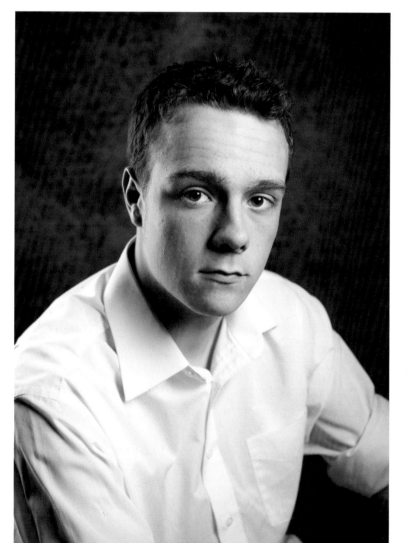

Think a little beyond your normal "vanilla" options when choosing backdrops.

This warm backdrop, from Shooting Gallery Backgrounds, is called "Pinkalicious."

I think it's a good idea to keep a few traditional, timeless backdrops on hand.

next year? The year after that? By predicting the life expectancy of a backdrop trend, you may be able use it for a couple seasons and sell it before it goes out of style. Then, you can start the cycle over, reinvesting in the next trend.

Trendy backdrops aside, I think it's a good idea to keep a few traditional, timeless backdrops on hand. Some of the master's muslins that are often associated with portraits from yesteryear can be exactly what clients are looking for—and if you don't have them to offer, those clients may go to a photographer who does. Plus, these traditional backdrops are always good for professional business headshots and portraits. Consider a good balance between traditional and trendy to offer a wide enough breadth of options for your clients.

The studio backdrop market is currently exploding. New vendors are popping up every month and new material designs and patterns show up almost daily. That's just how the industry is moving and growing. This movement and growth is a good thing. With so much variety and selection available, photographers can offer clients a different selection than competing studios—or at least the chances of having the same backdrops as other local studios is less likely.

The massive selection can be overwhelming at times, especially when you want to try something new, but in the end it's better for everyone—photographers and clients.

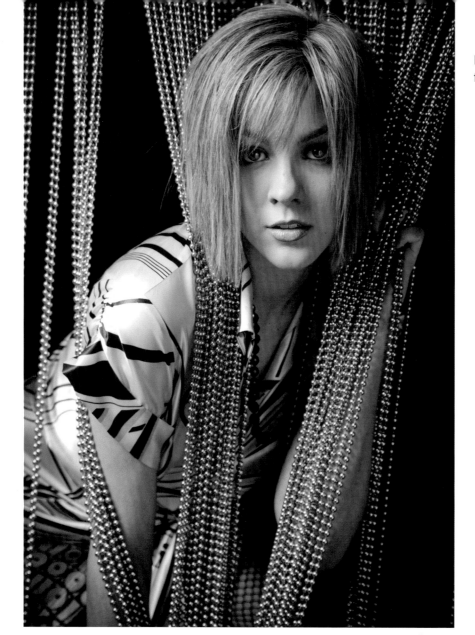

Beaded curtains can make a fantastic backdrop.

This barn-wood door was a great addition to my studio's backdrops.

13. Creative Backdrops

Take a stroll through your local hardware store and you'll discover all kinds of background options.

I've talked a lot about fabrics, wrinkles, and hanging backdrops—but not all background elements need to be fabric or paper. Fun and unique options are all around us, we just may not recognize them as such. For instance, a beaded curtain can be a great backdrop that adds a little pep to a portrait. Leave it hanging behind your subject for one frame, then let her peer through it for another.

Home Store Options

You can use anything as a background. The trick is to start thinking about everyday items as useful backdrops to portraits. Take a stroll through your local hardware store and you'll discover all kinds of background options like paper blinds, panelling, curtains, drapes, screen doors, corrugated panels and more. Once you start thinking outside the confines of traditional studio portraits, you open yourself up to more creative and fun opportunities.

Found Objects

I recently noticed an old barn being dismantled not far from my home. I stopped and asked the man doing the work about buying a section of barn wood that I might be able use in my studio. I ended up buying the hay door from the top of the 100-year-old barn. At about 9x8 feet, it was perfect. While not everyone has the means, or opportunity, to put an old barn door in their studio, you have the opportunity to think more imaginatively about what makes a backdrop or background.

Creating a unique and fun backdrop doesn't have to be complicated. Photo by Shannon Sewell.

Dangling Props

Dangling props are another great idea for adding dimension and creativity to an otherwise bland backdrop. A current trend is hanging chandeliers in the portrait—sometimes in the foreground, sometimes in the background. This hanging prop idea can be extended to just about anything to add visual interest. Plus, when you shoot at wider apertures you can minimize the sharpness of the hanging objects so they become muted but still add a simple, interesting element to your portraits.

During Christmas portrait season you might hang giant paper snowflakes or glass ornaments around and behind your subjects. Even hanging Christmas lights in the background can add a little festive flavor. The possibilities truly are endless—you're limited only by your imagination.

Even hanging Christmas lights in the background can add a little festive flavor.

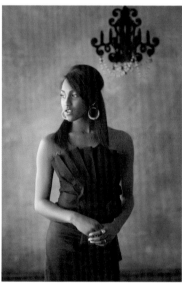

Chandeliers, alone or in groups, make for a very interesting background. Photos by Gary and Pamela Box.

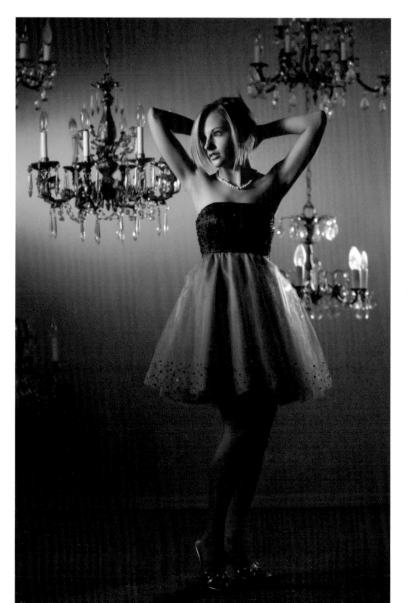

Hanging cutouts set the stage for this fun portrait. Photo by Shannon Sewell.

Christmas lights can make for a very pleasing background.

Design It Yourself

Making your own creative backgrounds is often born out of necessity—especially when your subject wants to incorporate their interests. For example, a student who plays in the high school band might want to incorporate music. In that case, an option might be to adhere dozens of sheets of music to the wall. Or if a senior is very into fashion, perhaps creating a wall full of fashion ads and photos would be a cool idea.

There's No Right or Wrong

There's no right or wrong when it comes to creative backgrounds, so look around you wherever you are. Head out to some stores you don't frequent—or those you do—and see what strikes your fancy. Here are a few ideas to get your creative juices flowing:

Even a concrete wall can add moodiness and feeling to a portrait.

1. Hanging lights
2. Hanging fabrics
3. Creating paper elements and cutouts
4. Newspaper-covered wall
5. Brick, hardwood, rock, or distressed-wood panelling
6. Concrete walls
7. Painted designs
8. Old doors

Next up, we'll see just how creative other pros are getting with their backdrops and backgrounds.

14. "Pro-pinions" on Studio Backdrops

As photographers, we're drawn to each other's processes—thought processes, post-production processes, lighting processes, and all the other aspects of the photographic process. Maybe it's something to do with the intrigue of watching art being made, or perhaps we want to learn how to be more efficient in our own processes. Whatever it is, learning how other pros work strengthens the photographic industry and helps foster more talented up-and-coming artists. This can be a touchy subject. Some photographers feel threatened by helping other photographers, but if everyone is creating higher quality work and can charge accordingly, it strengthens the industry as a whole. That's as deep as I'll get into that discussion here.

It was with that voyeuristic thought in mind that I talked with several talented professionals about their approach to choosing, using, and storing backdrops. They generously shared some worthwhile wisdom and knowledge for both studio and location shooting (covered in chapter 20).

For this chapter, dealing with studio work, I talked with Shannon Sewell of Shannon Sewell Photography (Portland, OR), Gary and Pamela Box of Box Portrait Gallery (Tulsa, OK), and Jen Basford of 3 Girls Photography (Edmund, OK).

Shannon Sewell

SHANNON SEWELL PHOTOGRAPHY ■ WWW.SHANNONSEWELL.COM

Shannon Sewell's creative portraits tastefully blur the lines between fashion and fairy tale. Beautifully styled and always one-of-a-kind, her work offers a level of uniqueness that draws clients from all over the country. From wardrobe and colors to backdrops, backgrounds, and creative sets, she makes it easy to get lost in her imaginative portraits.

Shannon's first priority for every session is lighting, but maybe not as you'd expect. She's a natural-light shooter, both in the studio and on location, so she's always conscious of how the light looks on her background and subject

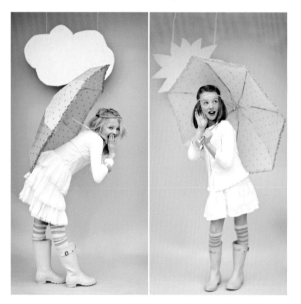

ABOVE AND FACING PAGE—Photos by Shannon Sewell.

areas. As a result of the natural lighting, most of her portraits are evenly lit with soft, subtle shadows. This is great for children, who make up a large part of her clientele. The only light modifier she uses is the occasional reflector to balance tones or fill shadows, but even that's rare. The natural-light setting allows her to use wider apertures, and it's that combination of soft, natural light and wide apertures that give her portraits the fairy-tale feel that she's known for.

Her portraits aren't standard fare by any account. A quick glance through her work and it's clear that Shannon's not one to use ready-made backdrops. She wants her portraits to tell a story rather than be just a "pretty photo" or "just a portrait." This is why standard muslin-type backdrops don't figure into her work. It's not that she doesn't find value in them—she acknowledges that talented photographers use them all the time—they simply don't fit with her creative vision. Her creative storytelling simply wouldn't work with a master's muslin.

"Part of what I love about what I do is the creation of something new and never seen," she says. That uniqueness is a selling point for her and one of the reasons she's always booked. But it also just wouldn't be possible if she were

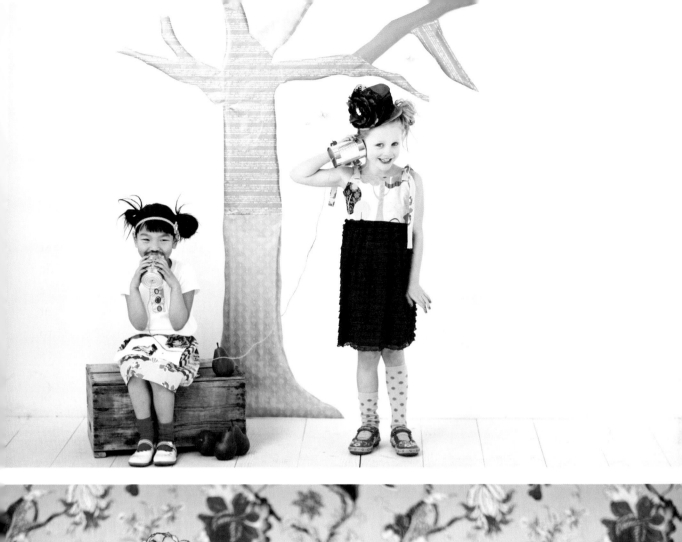

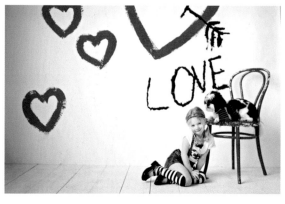

using backdrops that other photographers could purchase.

Instead, Shannon prefers to create her backgrounds using different elements that add depth and dimension. For example, she'll hang real tree branches or paper cutouts from the ceiling, or hang lengths of fabric against a wall. "I use a lot of paper and fabric for my backgrounds. I love both because they are recyclable and reusable. Fabric has been known to be a studio backdrop one day, and a throw pillow in my house the next," she says.

Adding depth and dimension is important in Shannon's work because of the wide apertures she uses. She carefully chooses what elements to add to the foreground or background, knowing they will go soft at f/1.8 (one of her most-used apertures). Most portrait photographers need only to worry about the subject and the background, but Shannon is always thinking in three dimensions.

Shannon also has a one-time-use rule when it comes to backgrounds and backdrops to

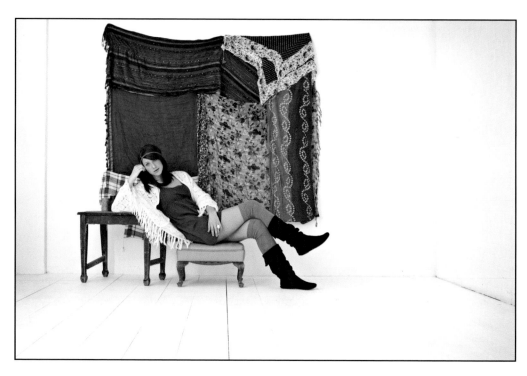

Photo by
Shannon
Sewell.

make sure her clients are getting a truly unique product. "Pretty much every shoot is different," she says. "There are a few staples like white and gray seamless that I incorporate often, but anything with its own personality only gets one chance to shine."

Background and set concepts are a collaborative effort between Shannon and her clients. Before a session, she and her client discuss ideas for the type of look they want. They plan out a theme, colors, fashion, and any other additional elements they might use. That way, everyone is on the same creative page for the shoot and knows what to expect for the final portraits. These discussions are important because they help direct the flow of the shoot and keep it on track during the session. Additionally, this careful planning lets Shannon know she's not wasting time by creating portraits her client isn't interested in.

When it comes to background storage, Shannon really lucks out. Because she doesn't use typical backdrops and backgrounds, she has little need for an elaborate storage plan. "I have a 4x4-cube cubby system in my garage. I organize each cubby by color or theme," she says. The cubbies get switched out after each shoot so she doesn't reuse elements for another session. The occasional longer pieces, such as a roll of seamless, are stored across the top of the cube system.

Shannon's inventive use of non-standard backdrops and background elements should get you thinking. Backgrounds don't always have to be fabric drops—and there's no reason you can't experiment with all kinds of textiles. (*Note:* Shannon also does a lot of outdoor shooting as well, and I talked with her about her process for those shoots. See page 150 for the second part of our discussion.)

Gary and Pamela Box

BOX PORTRAIT GALLERY ■ WWW.BOXPORTRAITS.COM

Photo by Gary and Pamela Box.

Box Portrait Gallery, in business since 1989, specializes in senior and family portraits shot both in-studio and on location. Their work is known for its unique charm mixed with classic style. For this interview, we talked primarily about their studio work.

Gary and Pamela use all kinds of backdrops and backgrounds, from muslin and canvas to wrinkle-free and DIY setups. They're not picky about the material their backdrops are made of—they can, and will, work with anything. Instead, they're more concerned with having the right color and achieving the look they're after. "A background can be anything," Gary says emphatically. "Background options for us are open-ended."

Photos by Gary and Pamela Box.

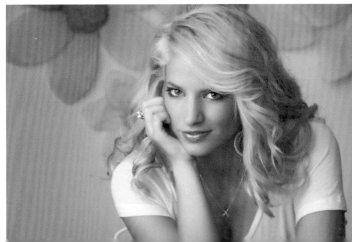

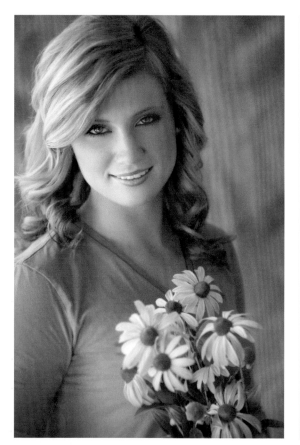
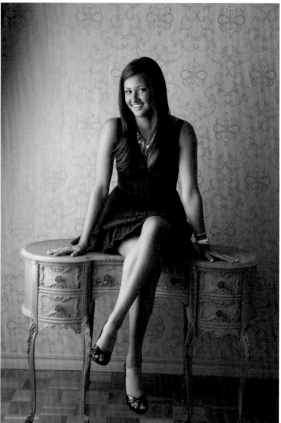
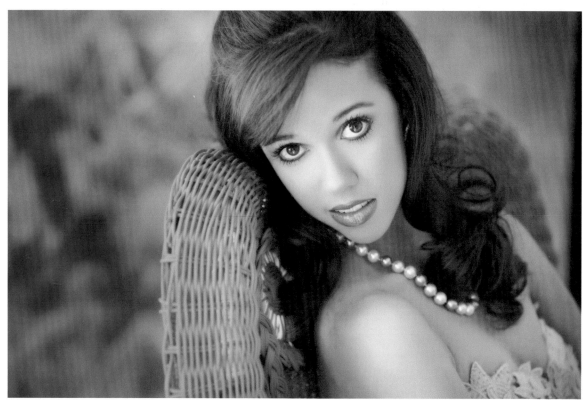

Photos by Gary and Pamela Box.

Just because they're comfortable using almost anything as a backdrop doesn't mean they take what they can get. In fact, just the opposite. Gary and Pamela's decisions are made based on color. Gary says, "We study the fashion industry and are very aware of what colors are coming down the pike. Pantone, who pretty much defines color, publishes a fashion report two or three times a year on the hottest colors among designers and the fashion industry." That's a very good indicator of the kinds of colors they can expect for the upcoming season. "If the hot color is going to be turquoise, then you better have backgrounds that are going to look good with turquoise," Gary explains.

Luckily, the color swings aren't too dramatic from one season to the next, so backdrops can often be used for several seasons. Gary says, "Once you build up a catalog of backgrounds, you'll find that some you won't use because it's jut not a hot color at the time. But in a year and a half, one of the colors in that backdrop might be really hot and so we're back to using it again."

For Gary and Pamela, another important consideration when picking colors is making sure they have backgrounds that work well with the school colors of the surrounding high schools. "You get sports jerseys and uniforms coming in, so you need to have something that goes with them," says Gary. That's something to consider for any photographer who does senior portrait work.

The Boxes are always on the lookout for new backdrops, and only occasionally get rid of old ones. The result of constant acquisition means they have somewhere in the neighborhood of three-hundred different backdrops and background set options—many of which they may not have used in two or three years. Included in that number are painted walls, wallpapered walls, and all kinds of fabrics.

Storing that many backdrops and backgrounds might sound like a challenge, but Gary and Pamela have it figured out. In a similar manner of other photographers I talked to, Gary and Pamela built a cubby system that's 8

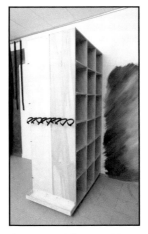 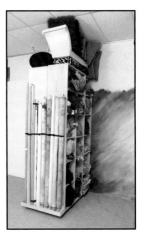

One side of Gary and Pamela's cube system holds smaller backdrops. Photos by Gary and Pamela Box.

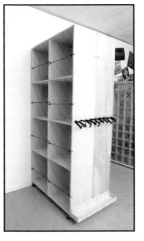 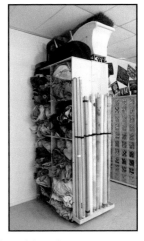

The other side of Gary and Pamela's cube system is set up to store larger backdrops. Photos by Gary and Pamela Box.

feet high, 4 feet long, and 3 feet wide. In it, they store about seventy backdrops. Talk about efficient. One side is faced with eighteen cubes that are each 16 inches square. These they use for smaller muslins, fabrics, and tapestries. Two (sometimes three) of these backdrops, wadded up, fit comfortably into each cubby, so those eighteen cubes hold roughly forty backdrops.

The other side of the storage unit is faced with eight cubes that are 24 inches square. These are used for large muslins and accommodate about sixteen to twenty backdrops (again, two per cubby). A bungee cord across the face of each cube keeps the backdrops from rolling out.

On the end of the cubby unit, they are able to store nine rolled canvases or muslins vertically. On the bottom, the rolls rest in a small tray.

A roll-around wall at the Box studio. Photo by Gary and Pamela Box.

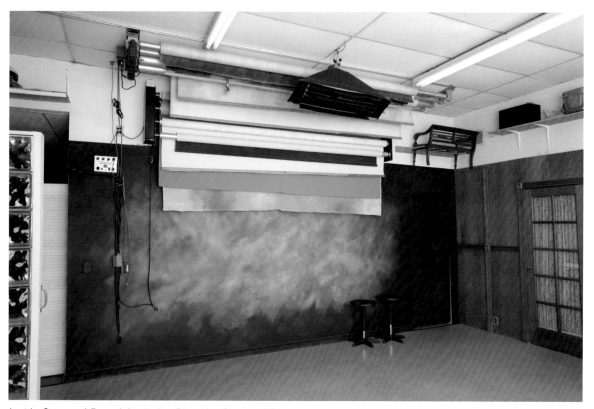

Inside Gary and Pamela's studio. Photo by Gary and Pamela Box.

Photo by Gary and Pamela Box.

Hook-and-loop enclosures keep each backdrop vertically in place. Lastly, they even store a few props on top. This mega-storage cubby system is downright impressive. Photographers, we all just ran out of excuses for not having enough storage!

In their main camera room, a 22x32-foot space, all the walls are painted for background use. They also have a few 6x7-foot DIY "roll-around walls" made of wood framing and drywall. Each of these has two sides that can be painted and decorated as needed.

Gary and Pamela's main camera room also features eight motorized roller systems (two sets of four) mounted to the ceiling. To make the most of these motorized rollers, the bottom rod of the mounted canvas does double-duty

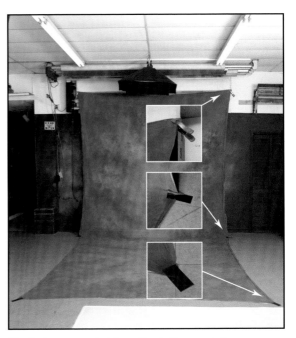

Muslin is suspended from the bottom rod of a canvas backdrop. Photo by Gary and Pamela Box.

as a support for other backdrops, like muslins. They roll the canvas down, and then clamp a muslin to the canvas's bottom-edge dowel using regular spring clamps. Once the muslin is clamped tight horizontally, they raise the canvas back up. To keep the muslin background tight, they use gaffer's tape where it meets the floor to ensure as wrinkle-free a surface as possible. If it's a large muslin for full-length portraits, they stretch the it out to its length and tape the front corners as well.

Gary and Pamela work with very controlled lighting for their studio work, often shooting with strip lights and other controllable modifiers to make sure the light that hits their subject isn't also hitting the backdrop. They always light the backdrop and subject independently of one another.

When asked about tips or traps to watch out for regarding backdrops and backgrounds, Gary and Pamela had a good bit of advice that is often overlooked. It's about understanding contrast. "One of your basic graphic rules is that the eye navigates to the object of greatest contrast. You're going to look at the thing that's most different," Gary says. "If you've got a red outfit, my number one pick for a background will be a red background because then everything is red—what's not red is the person, and again, that becomes the predominant subject."

A mistake they often see is putting a subject in light clothing against a dark background. In this setup, the light clothing becomes the most different thing, and so instead of looking at the person or the face first, viewers end up looking at the light clothing first. In the illustration below, you can see that the white square inside the black box (left) looks bigger than the black square inside the white box (right)—even though they are exactly the same size. Gary cautions that the same illusion can happen in portraits. "If you put your light-clothed senior on a darker background, you're not doing her any favors. You're adding one size to her." Gary and Pamela's advice: match the background and the clothing.

The white square inside the black box (left) looks bigger than the black square inside the white box (right), but they are exactly the same size.

Jen Basford

3 GIRLS PHOTOGRAPHY ■ WWW.3GIRLSPHOTOGRAPHY.COM

Photo by Jen Basford.

Three words come to mind when looking at Jen Basford's portraits: fun, vibrant, and crisp. Her portraits are always full of poppy color and unique textures, and her posing is the perfect balance between spontaneous and suggested—but always natural. She does both studio and location work, but for her interview we focused mainly on studio work.

Jen owns 3 Girls Photography, where she specializes in portraits of seniors, children, and families. She's definitely not one for traditional backdrops and backgrounds. "I'm not a fan of the old masters look and anything dated. I avoid muslins at all cost," she admits. "I don't like the look, and they are a nightmare to put up."

She does, however, admit to using canvas backgrounds ("Once in a while if they are unique," she says), but she prefers to use them as walls with added faux baseboard to give them character, as discussed in chapter 4. She also uses backdrops by White House Custom Color (WHCC). "I love WHCC's backgrounds because I can go online, order them, they show up in a few days, and it takes me roughly a *minute* to put them up." I touched on these backdrops earlier in chapter 9, and I agree.

Jen is not one for overusing trendy looks or even unique backdrops. "Trendy or distinctive

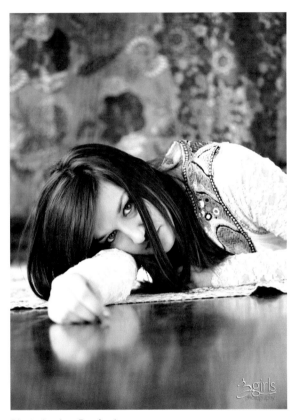

Photo by Jen Basford

backdrops have a short run time at the studio," she says. "I never want images to look the same year after year, so we really limit the use of those types of backgrounds. More subtle backgrounds may stick around a while, but I will take extended breaks from them and mix up how I shoot with them in the meantime."

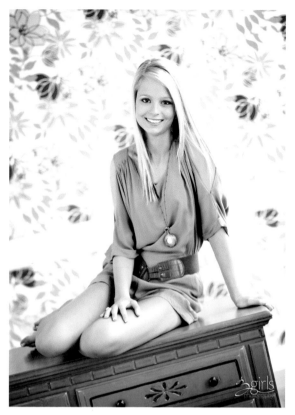
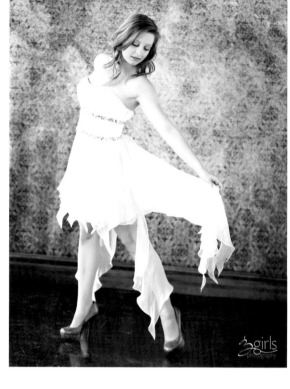

THIS PAGE AND FACING PAGE—Photos by Jen Basford.

Jen finds inspiration for backdrops all around her, and especially from fashion catalogs and various websites. A trip to the hardware, craft, or fabric store often pushes her from inspiration to DIY production. "I love to use fabrics in lots of different ways—on the wall, clipped to stands, draped over things, and so forth," she says. "I also love ceiling tiles. I love creating colorful or neutral textures and patterns that can easily be changed out on 4x8-foot sheets of insulation board."

Creating and acquiring new backdrops is a monthly, and sometimes weekly, occurrence for Jen. She says her choices for backgrounds depend on where she wants to go with her images and where she sees color and fashion trends heading. Her ultimate goal, of course, is to come up with unique and different designs and ideas that no one else is doing.

"Be unique and create your own individual style," she said, when asked if she had advice for other pro photographers. "Everyone can do 'on location' and everyone can purchase 'standard backdrops' from any backdrop company. Find things to inspire you to create your own studio image and look. Visit a boutique that you like. Go to a fabric store. Check out color trends from Pantone. Look for interesting textures. And keep changing it up year after year."

That last line may be the most important part of her advice. If you're not changing and adapting along with the industry, you're going

Photo by Jen Basford.

to find yourself in a puddle when everyone else has moved to a pond.

Jen has the luxury of shooting in a 1,000 square-foot camera room with 100 percent natural light. That allows her to use wide apertures, which she uses for creatively blurring backgrounds. But she's not opposed to using artificial light. She says, "I love to play with lights of all kinds. I'm always on the hunt for new and creative lighting with studio lights." She uses lights indoors and out if it works with her vision.

Storing backdrops at 3 Girls Photography is just as unique as many of their DIY backgrounds. "I store fabrics and WHCC backgrounds in dresser drawers in our camera room. Rugs, ceiling tiles, and anything that goes up and down easily is stored in a cubby system," she says. She also uses a standard roller system for larger backdrops. "Our canvas backgrounds are rolled up and stored in a corner of the camera room, or on a roller system in our second camera room," Jen notes.

15. Discovering Existing Backgrounds

Some of my favorite portrait sessions are done outdoors. I love the natural settings and endless variety of backgrounds, textures, and perspective. Be it urban or rural, farmland or forest, the extensive variety of outdoor locations makes outdoor

I love the natural settings and endless variety of backgrounds, textures, and perspective.

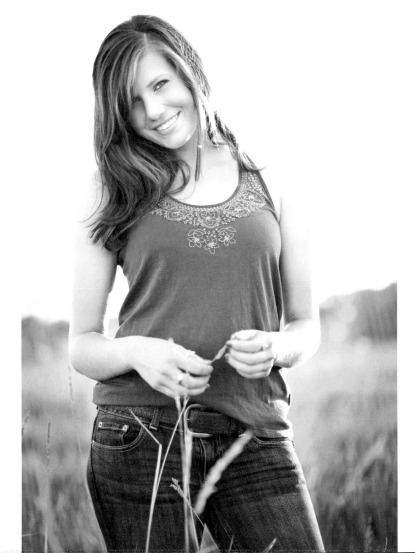

Outdoor portraits can be fun and interesting.

portraits fun and interesting. Some locations are better suited for portraits than others, and there are many considerations to take into account when looking for (or setting up at) those locations.

In this section I'll talk about what to look for on location, how to see locations differently, and how to turn just about any location into a good location. I'll also provide several examples of types of outdoor locations that I know work well from experience.

Scouting Locations

Whether it's a great location or a beauty-challenged location, take a moment to really see your surroundings when you arrive. Whenever possible, I scout a location a day or two before the shoot—or at least arrive before my clients so I can walk around and plan my backgrounds. Doing so makes me look more professional when my clients arrive, because I can take them right to the spots we're shooting at and immediately start positioning them. This is especially important during family portraits, because idle time means wandering children.

Scouting a day or two ahead of time also allows you to pre-visualize spots that might work well in combination with studio lighting or different props. In the end, you're more likely to have a good session if you're prepared for the location and know you aren't walking into any surprises.

Cataloging Locations

I also suggest starting a photo catalog of locations you might shoot at. I can't tell you how many times I've been out for a run or visiting someplace with my family—or even running errands—

Scouting locations before the session helps things go more smoothly.

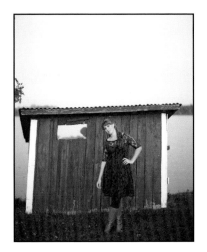

Cataloging successful locations (as well as ones you want to try) will provide you with quick answers when planning your next location shoot. Photos by Jacob Rohde.

and seen a location that I thought might be great for portraits. Then, inevitably, I'd forget about it the moment I get home. To combat this problem, I started taking photos of these locations with my iPhone and cataloging them. Doing so has made a big difference in choosing outdoor locations for clients when they ask for a particular look or setting.

Cataloging is easy to do, but it takes some discipline. Make some folders on your computer with names denoting different location categories (rural, woodsy, forest, urban, grunge, brick, etc.). Your list may grow over time. Then—and this is the most important part—keep a camera with you at all times so you can immediately snap pictures of the locations you think would work well. It could be your phone or any other pocket camera, but the point is to always have it with you. In those moments when you're out with your family and think, "Wow, this would be a great spot for portraits," you have to be able to quickly snap a few shots.

The second most important part of this process is making sure to transfer your location photos to their respective folders as soon as you can and add some notes in the metadata fields about where the locations are, why you like them, or what you types of portraits would work well there. If you think you might have a hard time remembering where it was, write a note about the location on a piece of paper and take a photo of the paper right after your photos of the location. Believe me, you will thank yourself later for those notes when you're scrolling through dozens of random location shots. It will provide you with a quick answer when you ask yourself, "Why did I like this location?"

What Makes a Good Location

A photographer friend of mine once told me he could make great portraits in a parking lot just as easily as in a beautiful arboretum or botanical garden. At the time I didn't believe him. But that was a long time ago. Now, I tell my assistant the same thing— because I know it's true. It's all about how you look at things, the lens and aperture you choose, and the positioning (yours and your subject's).

You won't always have the ideal locations for outdoor portrait sessions. Sometimes, your client chooses a location they think is "absolutely gorgeous"—but when you get there you realize they've been talking about a small flower bed with a handful of pretty flowers on the ground. It's not quite the beautiful location *you* had in mind. If a client suggests a location to me, I always do my best to check it out before committing to shooting there. More than once, I've shown up at the client's choice of location only to find it less than dazzling. Usually, though, I'm able to make it work because I know what to look for in any location and how to alter its appearance.

Transforming Any Location into a Good Location

If you know what to look for, great outdoor backgrounds are everywhere—the trick is knowing how to see them and distinguishing what makes them good. A single location can easily look like two or three different locations if you take the time to make a few changes. Here are five sure-fire ways to change your outdoor background:

If you know what to look for, great outdoor backgrounds are everywhere.

This portrait was taken in the senior's yard. The angle and tight cropping made all the difference.

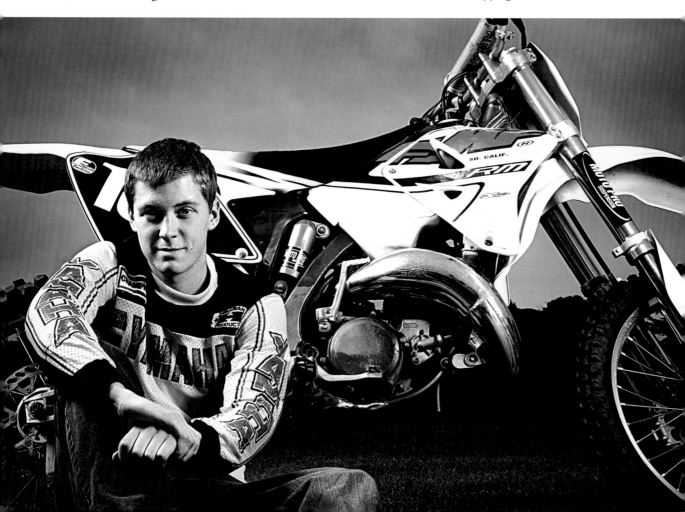

This broken-down RV turned out to be a great textured background for a sunny senior portrait.

1. Change your position.
2. Change your subject's position.
3. Change your lens (telephoto *vs.* wide-angle to shift compression).
4. Change your perspective.
5. Open up your aperture.

While that list may sound obvious, these are all things that may not immediately come to mind in the middle of a shoot, so it's

good to remind yourself of them before you head out to your location.

Changing your position can be the difference between a green leafy background and a worn brick wall. Don't underestimate such a simple change. Depending on your position, if you move 90 degrees to the left or right of your subject, you may have an entirely new portrait. At the very least, it might be different enough to offer another choice for your client. Look around and maybe take a few steps to the left or right—or just move around a little bit. Small movements make big differences in outdoor portraits.

Changing your subject's position is just as beneficial as changing your own. But don't limit yourself to turning them left or right, consider asking your subject to sit down or squat, or even stand on something in the location like a log or a rock. Again, that minor change in position can alter the background enough to make the portrait appear completely different.

Sometimes just changing your angle a little bit can make a big difference in the background.

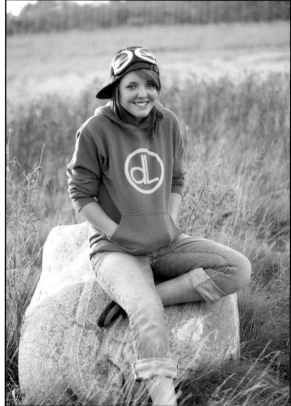

These two photos were taken in the same open field, only with different perspectives.

Change your perspective—your angle in relationship to your subject. Look down. Look up. Take note of the background above and beneath your subject. How would it change if you were to adjust your physical angle? Sometimes just changing your angle a little bit can make a big difference in the background, even if your subject is sitting on the ground.

Change your lens. Lens selection is a major factor in outdoor portraits. Here's why: a 35mm lens at f/2.8 will produce a much different photo than a 200mm at f/2.8 because the two different focal lengths will produce much different compression. The longer the lens, the more compressed the elements in the image

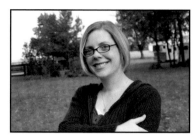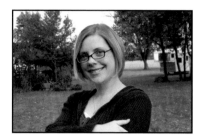

These photos were made using a 35mm prime lens. Changing the aperture produced varying background results. The first was shot at f/2.8, the second at f/5.6, and third at f/11.

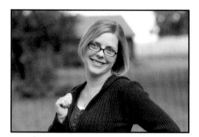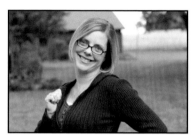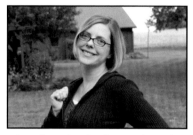

These photos were made using an 85mm prime lens. Changing the aperture produced varying background results. The first was shot at f/2.8, then f/5.6, and f/11. The model stood in the same position as above.

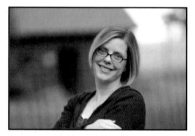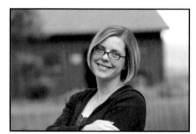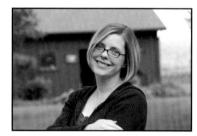

These photos were made using a 70–200mm lens at 200mm. Again, the first was shot at f/2.8, then f/5.6, and f/11, and again the model remained in the same spot. Notice the difference in background compression between the 35mm and 200mm photos.

become. Have a look at the images above. In all three sequences, the first images were shot at f/2.8—but with different lenses. Notice how the background changes with the focal length. The subject didn't move, but the background compressed as longer lenses were used. You can use compression to your advantage, especially when your location is less than stunning. Switching to a longer lens will let you, essentially, subdue the background elements because they will be so compressed and less recognizable than with a wider lens.

Keeping your subject the focus of your outdoor shoot is important—and it's made easier by using a wide aperture to

produce soft bokeh (blurred areas) behind and around them. The wider your aperture, the more blur you'll achieve. This is a good thing because you don't want the background details to take away from the subject.

Depending on my lens, I like to use an aperture wider than f/4.0 for my portrait work. In fact, I shoot many of my portraits using an aperture of f/2.8 or wider. If you're using wide-angle lenses, 50mm or wider, it can be tricky getting used to shooting at wide apertures. The distance from the camera to the subject also affects your focal plane, so I suggest focusing on the eye closest to the camera and practicing a lot before doing an entire shoot wide open.

Changing the Appearance of a Location

Aside from the changes mentioned above for altering an outdoor location's background, consider a few other options to change the way the location looks.

One way to change your location's appearance is to add an off-camera strobe (a speedlight or studio strobe). By merely adding a single strobe to an outdoor session you can change the look of the entire location. Some photographers miss this opportunity because they feel it's too much work to lug a strobe and battery pack to a location shoot. But if you are willing to do it, you'll set yourself apart from your lazy competition.

Another way of changing your location's appearance is by shooting at different times of the day. Everyone knows about the "golden hours" (one hour after sunrise and one hour before

One way to change your location's appearance is to add an off-camera strobe.

These two photos were taken in the same spot, but the second used strobes instead of natural light.

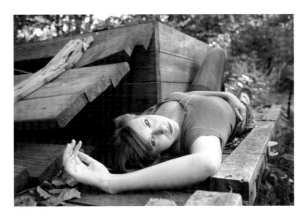
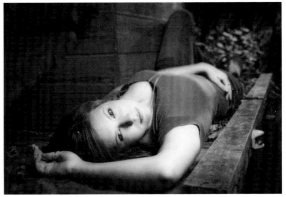

sunset), but don't forget that the light in a location differs throughout the entire day. If you find a location you really like, check it out at different times throughout the day to see if one time is more pleasing than another. Obviously, the midday sun will make an open field practically unusable—but don't forget about shooting in shady areas during that time. When the sun is pounding down on everything around you, even the shadowed areas lighten up and often produce beautiful light for portraits.

Shooting Times

When the great outdoors is your studio, you're limited by very little. One of the limitations, however, is natural light. Photographers often talk about the golden hours of the day as the best time of day to shoot, and there's some truth to that. During the golden hours the sun is warm, soft, and easy to work with. The sun is lower in the sky, so its light comes from the side, as opposed to overhead—and we all know that harsh, direct overhead sun does nothing good for portraits (unless you like your subjects with raccoon eyes). However, no successful photographer limits themselves to two sessions a day, one in the morning and one in the evening.

If you find a location you really like, check it out at different times throughout the day.

The time of day can have a huge impact on the look of the background—and, of course, the subject.

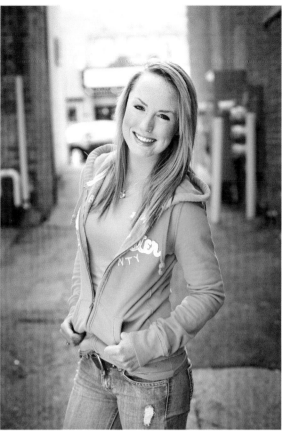

These two photos were taken in the same alley, but with different lighting and different positions.

In order to shoot outdoor portraits throughout the day, you need to be savvy about choosing a location with plenty of shade and usable light. This goes for all outdoor locations, not just woodsy or rural spots. I'll talk more about this in each of the upcoming sections on specific types of locations.

Same Location, Different Looks

You can't shoot every portrait session in a new location, but you need to be able to make a single location look like several others. What I mean is moving around the same location—walking a lot (not just 10 or 20 feet to the right or left), placing your subject(s) in different spots, and changing your shooting angles and positions. All this adds up to seeing the same location in many different ways. Not only do you need to see it differently for each client, you need to see it differently for multiple clients. If you shoot there again, you don't want to duplicate your shots—

especially if you shoot senior portraits. Seniors are all about being unique, so you'd better be able to deliver uniqueness, even if you're shooting at the same place you photographed their best friend. Don't get me wrong, shooting in the same locations is good; it makes sense because clients can trust your consistency. But you need to be able to see that location in many different ways to get maximum usage out of it.

Permission to Shoot

It may sound like a no-brainer, but I have to say it: If you're shooting outdoors, no matter the location, make sure you're on public property. If you're not sure, try to find out. Some shop owners in urban settings get uneasy when a photographer brings a subject out in front of their store or to their back alley. Be smart; if you carry your business cards and proof of insurance, you should be okay for most situations. Most of all, be courteous. If someone isn't comfortable with you shooting on or near their property, don't make a big deal of it in front of your clients. You're the professional, so act like it. Pack up and move on.

Popular Location Categories

In the next few chapters, I'll address some of the most popular outdoor location categories I use for portraits. By no means are these the only types of outdoor background settings, but they are the ones I tend to use a lot in my portrait work and are fairly popular among other pros.

> If you're shooting outdoors, no matter the location, make sure you're on public property.

Using unexpected angles can open up new background opportunities. Photo by Jacob Rohde.

16. Architectural Backgrounds

Here, the architecture held special meaning; it's where the husband proposed to his wife.

Using architectural elements in your portrait backgrounds can add personality, enhance compositional interest, or establish a specific location. I recently did portraits of a couple in front of a local bakery. To most viewers, it's your standard kissing portrait. To this couple, it held much more significance because it was the location where the husband proposed to his wife while drinking coffee and eating fresh pastries. To have portraits made in that same location, now that they were married, made a lot of sense to them—even if other viewers didn't find the storefront particularly photogenic. It was personal to my clients' taste and they loved it.

That's a very personal reason to include a specific landmark, but architecture chosen to appear in the backgrounds of portraits can serve all kinds of purposes—personal, emotional, character-defining, compositional, mood-enhancing, and more. Does architecture always need to be so intentionally meaningful? No, not necessarily—but, as a professional, you should be thinking about what the background says about your subject, whether it's a brick building or flowering tree.

Defining Locations or Emotional Connections

Depending on your subject, the location could be important to their portrait. They may explicitly want something in their portrait that says "Los Angeles" or "Chicago" or "New York"—or even "Bozeman." A great way to define a location in a photo is by including landmarks or recognizable architectural elements. We've all seen vacation photos of friends standing at the water's

This portrait was taken in front of the family's new home.

edge with the Golden Gate Bridge behind them, or a snap from the top of the Empire State building with their face blown out by the on-camera flash. You look at those photos and immediately know where they were taken. That might be exactly what they're looking for.

For example, a family portrait client may want their portrait made in front of their house. Most viewers who know them would know it's their house, even if most of it is cropped out. The point is, it's a family portrait that tells the story of home-sweet-home for your clients.

In the wedding photo at the top of the facing page (by Simon McConico of Valo Photography), the bride and groom were married at Wisconsin's beautiful Milwaukee Art Museum. For this reason, including the beautiful architecture of the museum helped personalize the images, but it also added an element that would be widely recognizable to others—which might be important to the couple. Perhaps they have family that live out of state and they want to send something that says "Milwaukee." And let's face it, you don't pay to have your wedding at a beautiful art museum and *not* want to see the creative architectural elements in your photos.

On the other hand, your clients may not care if other viewers know where the portrait was made, as long as it's obvious to *them*

As a professional, you should be thinking about what the background says about your subject.

Including the architecture helped document the location this couple chose for their wedding—the Milwaukee Art Museum. Photo by Simon McConico.

Here's another portrait made at the Milwaukee Art Museum, this time at sunrise. Photo by Jacob Rohde.

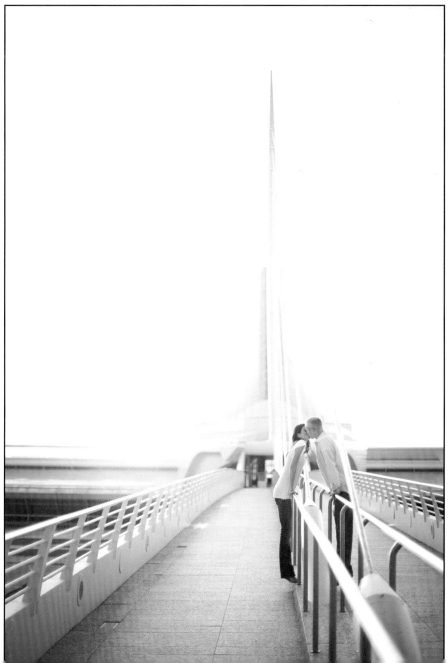

(as with the couple at the beginning of this chapter). Talking with your clients about their preferred location will provide worthwhile insight as you build their portrait. Find out why they want the landmark or structure in their portrait. Is it because it reminds them of a family member? A joyful time in their teens? Their courting years before becoming husband and wife? Knowing the connection will dictate how you compose the portrait, and possibly the mood you want to convey.

Have fun with it and be intentional. Understanding why a client wants their portrait made in a particular location will make their session more enjoyable—and it might be the difference between a good sale and a great sale.

Composition and Framing

When incorporating a landmark, building, or architectural element, the challenge is doing it in a way that works with the

Talking with your clients about their preferred location will provide worthwhile insight.

This senior portrait was taken in the historic town square in Woodstock, IL, with the iconic opera house in the background.

portrait and keeps the subject the focus. That's where composition, framing, and creativity come in. Including architectural elements in your backgrounds gives you a chance to be creative and push you outside your comfort zone if you let it.

In the top-right photo by Simon McConico, the architectural beams draw your eyes directly to the couple. The shadow cast from the wrought iron fence on the sidewalk creates leading lines running parallel to the beams—and the couple was placed right at the intersection. The repeating lines and light/dark contrast finish this portrait brilliantly. When you take the time to intentionally compose your portraits and employ the elements around you, you can create beautiful works of art.

While Simon's example may seem complicated (and luck may have played a role in finding that location at the exact right time of day), you don't have to make it difficult or as intricate. Framing subjects using architecture can be as simple as standing them in a doorway or framing them between two buildings. Above are some examples of using architectural elements to frame and compose effective portraits. The main thing is to be able to recognize a useful location when you see it.

Mood Swings

Architecture can instantly influence the mood of a portrait. While strategically placed lighting can quickly add drama, a crumbling old brick building evokes a different mood than a mirror-windowed skyscraper—no matter how each is lit. A graffiti-covered doorway sets a different mood than a white picket fence. Consider the following contrasts and how they may affect a portrait:

> Cramped *vs.* open
> Old *vs.* new
> Wood *vs.* stone
> Decaying *vs.* brand new

The mood of the portrait should match your subject. A portrait of a heavy metal band would probably look a little different than a portrait of a folk band, for instance. Imagine a metal band sitting in a field of long swaying green grass with the sun spilling from behind the side of a big red barn, the band members holding their guitars and wearing black leather pants. Their long hair catches on their spiked dog collars as the breeze gently blows. I realize I'm stereotyping metal bands here, but you get what I'm saying. That setting definitely wouldn't fit the mood of a metal band. On the other hand, that might be exactly how a folk band would like to be portrayed.

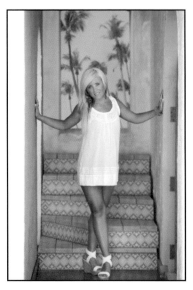

Architecture with a tropical flare perfectly suited this young woman's style and summery outfit. Photo by Gary and Pamela Box.

What to Look For

When considering architectural backgrounds for your portraits, it's easy to overthink things—and overlook useful areas. A few things to look for are natural archways, unique brick patterns,

Through careful composition, architectural elements can be made to frame the subject.

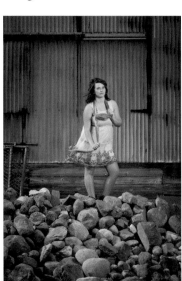

doorways with personality, spaces between buildings, stairways leading to doors and porches. This is only a minute sample of great architectural elements that can enhance the backgrounds of your portraits.

Don't be afraid to experiment and don't rule out anything. Your own town may have more to offer than you think, but if you're stuck creatively, try the next town over. Sometimes you can more readily identify what's architecturally available when you've never seen it before. On the other hand, you may be an expert on your town and know about really cool, unique architecture that others are overlooking. Sometimes looking at the same places with new intentions can make a big difference.

Again, don't forget to take photos to catalog new architectural elements that you think might work well for portraits.

Contrasting architectural styles create very different moods in these two portraits of couples. Photos by Jacob Rohde.

 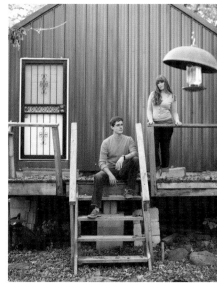

An industrial-looking architectural background suited this subject and her attire.

17. The Natural Landscape

Some of my best portraits are shot against the least expensive but most widely available backdrop around: nature. I love shooting senior portraits outdoors in natural light against nature's beauty. There's just something about the quality of light mixed with a wide aperture that makes for absolutely beautiful portraits.

Showing seasonal changes can add flavor to your outdoor backgrounds. Photo by Jacob Rohde.

Late summer scenes are naturally beautiful.

Over the years, as I've done more and more outdoor sessions, I've learned that several factors contribute to a great outdoor background.

Seasonal Changes

Seasonal changes affect the colors in your outdoor portraits, but they also play a role in the overall visual interest of the background. Every photographer has a favorite season, and summer and autumn are usually at the top of the list with good reason. In summer and fall, the trees create beautiful, pebbled light that pokes through the leaves and dapples your backgrounds. Winter and spring, on the other hand, can be depressing for lack of color and foliage. Without leaves and growth, trees can look ominous, pointy, and scary—none of which are adjectives you want to come to mind when talking about portraits (unless it's a Halloween portrait). Fall portraits, on the other hand, usually have a warm light and unmistakable color palette that everyone instantly recognizes as autumn.

Many of my senior sessions take place in late summer and fall, and almost always at the end of the day when the sun begins its descent. I find the setting sun in those seasons very predictable, which means I know how much time I have to work and I know what the light looks like in my most commonly used locations. I love having this sunlight coming through the leaves of a tree for a soft dappled backdrop with smooth bokeh.

Every photographer has a favorite season, and summer and autumn are usually at the top of the list.

Shooting at Any Time of the Day

As a professional, you need to be able to shoot at any time of the day, often outside of the golden hours. In this case, an open field would not be the best option, although you could make it work with a diffusion panel. The secret to daytime shooting is shade—plenty of shade. Shooting in the shade of a grove of trees will produce better portraits than direct sun every time because the light is flatter. That doesn't mean your images will be flat, especially if you use a reflector to bounce a little more light back into your subject. Using reflectors is a great way to add dimension in the shade.

Shooting in the shade of a grove of trees will produce better portraits than direct sun every time.

What to Look For

We've all said it one time or another, "The scenery here is just beautiful." But have you ever stopped to look at what exactly makes it beautiful? Is it the forest? The tall, flowing grass? The colorful flowers? Probably it's some combination of all those things. Unfortunately, beautiful scenes don't always translate well into portraits because our field of view is much wider than a lens's. So in order to make use of beautiful scenery for natural

Letting the forest go dark made the portrait more interesting and kept the emphasis on the subject.

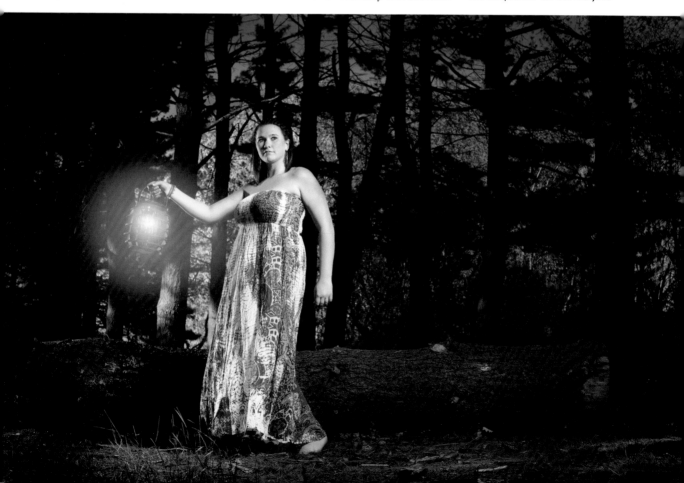

A tree can be used as a framing element.

It's important to be intentional about composition in outdoor portraits.

backgrounds we need to zero in on a specific area. Maybe it's just the flowers, or a single grove of trees, or just the tall grass.

This is where framing and composition come in. It's important to be intentional about composition in outdoor portraits. Seating your subject in the center of the frame directly in front of a tree probably isn't the best idea. Not only will he look like he's growing a tree out of his head, the frame will be split down the middle by a dark tree trunk that turns into a person. Instead, consider using the tree as a framing element. Try placing your subject at one side of the frame and let the tree anchor the other side. Don't be afraid to include branches from a tree to help frame the portrait, too—

just make sure you have enough tree in the photo. If only a tiny branch were poking into the frame it might look like an accident. The same goes for any other intruding elements. Of course, the tree is only one example. You can apply the same thinking to any other natural elements (always watching for things that seem to "stick out" of your subject).

And don't forget about changing your position and angle when shooting at natural locations. Doing so will open up a wide variety of background options. Shooting from a little overhead might provide a pleasing background of weeds and leaves, while lowering your position might let you include plenty of sky in your photo.

Trends

Trends come and go in outdoor portraits just as they do with studio portraits. It's up to you if you want to follow the trends . . . but how long will it be before the couch or armchair in the middle of an open field becomes clichéd? It probably already is. Still, if a client asks for it, I'd say it's a go. The point here is to be wary of trends and fads that will date your portraits and lock them into an era instead of leaving timeless impressions.

Some Great Natural Location Ideas

Open fields of grass or weeds or wheat

Well-manicured grassy areas

Forest preserves

Tree clusters

Curvy walking paths

Flowering and colorful weeds

Public recreation parks

Park trails

Ponds and surrounding areas

Shooting from an elevated angle can totally change the look of a location.

18. The Urban Landscape

Made up of brick, concrete, asphalt, chain link fence, peeling paint, old worn doors, and more, the urban landscape is ripe for creative portraits. The urban setting is perhaps more common

Clever posing made this urban image of a bride and groom all the more engaging. Photo by Jacob Rohde.

to clients than we think, after all, they see it every day. But as photographers we have the opportunity to show this overlooked background in a creative and different manner than many are used to. In a way, that's our job. That's what we're supposed to do.

What to Look For

Finding a unique, photogenic urban background isn't difficult—especially when you know what to look for. Take a walk around any downtown area and I guarantee you'll see a plethora of great spots to shoot, even if you don't immediately recognize them as such. A few great elements that make urban backgrounds work are patterns, repeating elements, leading lines, and contrasting elements. The most notable element, however, is texture. Texture is the reason why so many urban settings work. We're so used to seeing smooth studio portraits that we sometimes overlook the value of rich, random texture. I've had clients tell me their urban portraits look like they can feel them, even if the texture only exists on the wall behind the them. That's good. The photo elicits a visceral reaction—you can't ask for more than that when it comes to your own work.

By its very nature, the urban landscape includes texture. So what else should you look for? How about creative framing? You can creatively frame subjects in urban locations by placing them between buildings, in the opening of an alleyway, or inside a door or window frame. It could be just your subject's face that's framed, or it could be their whole body. Either way, the framing technique is a useful compositional tool that works especially well in urban settings.

Don't forget about repeating elements and leading lines, two other useful compositional tools that are readily available in urban settings. Repeating elements add visual interest to a portrait by increasing the sense of symmetry or balance. Both are good things. A few examples are windows, bricks, doors, storefronts, parked cars, or empty parking spaces.

Leading lines draw the viewer's eye to a specific place in the photo, which is usually the subject. This is another great tool

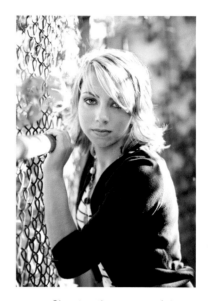

ABOVE—Showing the texture of the surfaces around the subject is a key to using urban backgrounds effectively.

FACING PAGE—Elements of the urban landscape often form effective framing elements. Photo by Jacob Rohde.

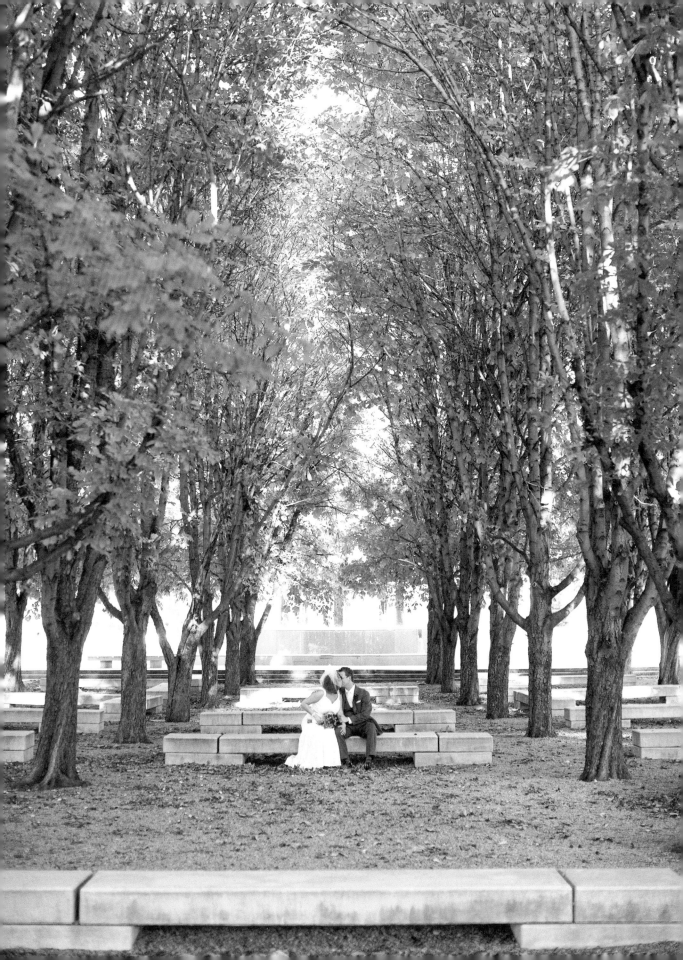

This photo is full of rectangles and squares—buildings, windows, the pattern on the model's shirt, and the cobblestone street.

that will add interest and intention to your work. Some good examples of leading lines are fences, railings, spindles, stairs, and well-placed shadows.

It's also a good idea, whenever possible, to find colors that match or complement your subject's wardrobe. You won't be able to do this in every instance, but in those instances when you can, that extra effort makes a portrait just a little more interesting. It's attention to subtle details like this that keeps new clients knocking on your door.

It's attention to subtle details like this that keeps new clients knocking on your door.

One way to increase

the drama is by

strategically adding lights.

Just as with natural backgrounds, you can quickly make a mediocre urban location look like a brilliantly planned set by making a few adjustments. Again, changing your position, your angle, your lens, your aperture—all those things mentioned in chapter 15—can alter the appearance of your location. Also, don't hesitate to bring out a studio strobe to your location. Urban locations often lend themselves to added drama, and one way to increase the drama is by strategically adding lights.

Safety and Permission

Don't take safety for granted. Urban settings are often full of broken glass, sharp corners, dirty surfaces, and other potential hazards, so use common sense. If you see a lot of broken glass, don't ask your client to sit down in it. If you see rusted nails or screws, move them out of the way.

Pay attention to no-trespassing signs and private property. If you're not sure whether the location you're in is private or public, chances are it's private. Again, use common sense and either find a different location or find the owner of the location and ask for permission to shoot there. Most of the time, people will gladly allow you to make a portrait on their property if they

The blue tones on this wall made it a perfect choice for a subject in a dark-blue dress.

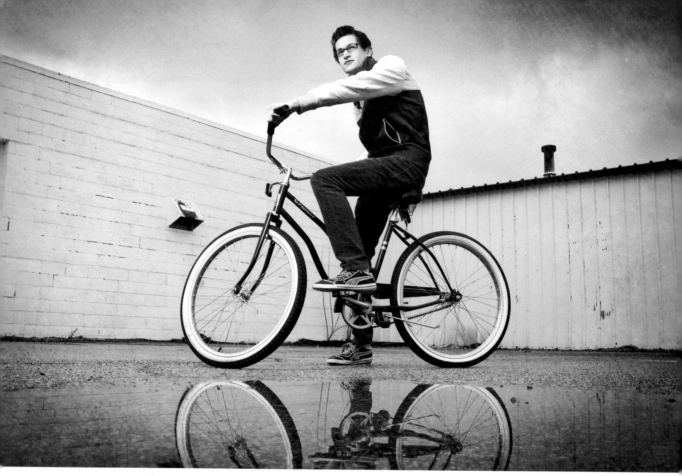

If in doubt, it's always best to ask permission to use a location *before* shooting.

know about it—but if they find you doing it without permission, you might find yourself in a heap of trouble.

Also, if a location looks sketchy, avoid it and find another. The last thing you want is any kind of confrontation. For example, I've done portraits in a local alley many times in the past and only recently had an issue. An intoxicated individual from the local bar came by and made things uncomfortable for a few minutes asking too many questions and threatening lame challenges. Then he wanted his picture taken with my headshot client. Luckily, I wasn't photographing a senior at the time, which would have made it more uncomfortable.

Some Great Urban Location Ideas

Outside coffee shops

Alleys

Brick walls

Stairs (with railings)

Chain link fences

Abandoned loading docks

Old shipping yards

Abandoned urban lots

Storefront steps

19. The Rural Landscape

The rural landscape is similar to other natural outdoor backgrounds, having elements like trees, fields, and bodies of water. The biggest difference is the addition of farmland and barns. Rural backgrounds tend to make for relaxed portrait settings that communicate a sense of the simple life. If you mix barns and farm buildings with the setting sun, you've got the recipe for some of my most popular portrait sessions.

What to Look For

Finding a rural landscape can be as simple as stopping off alongside a golden wheat field waving in the breeze, or as involved as asking

With its peeling paint, this wall was the perfect spot for a relaxed family portrait.

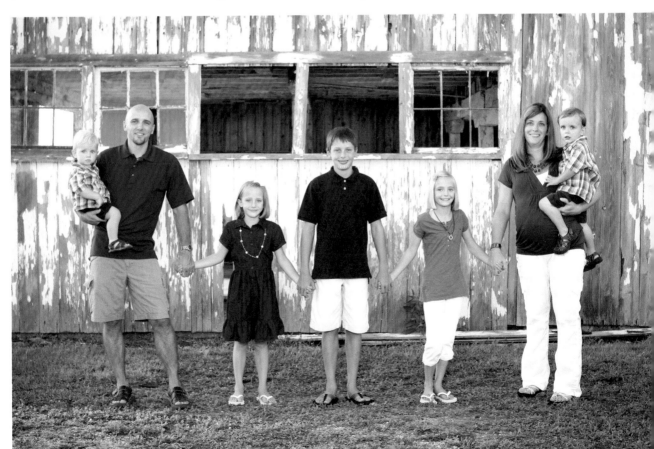

Big, red barn doors make a great background.

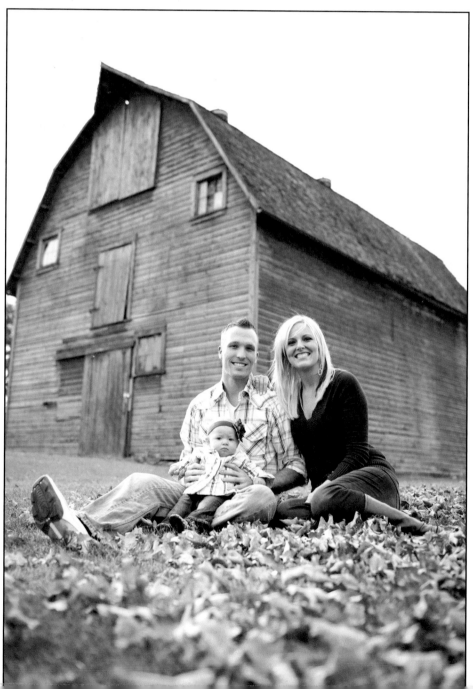

Placing the subjects a good distance from the barn can let you incorporate the whole barn in the background.

permission to shoot at a working farm or nursery in your area. However involved you want to make it, the following are a few things to look for that make this kind of location worthwhile.

Let's dispense with the obvious: barns. Big, red, aging barns are best, but others will work. The trick to using barns in your background is choosing how much of the barn to use. Sliding barn doors make for a great backdrop, as do the textured walls. If your client is bent on including the entire barn, top to bottom, as a background element, you're going to have to place your subjects a good distance in front of the barn and use a fairly wide lens. That will ensure the entire barn shows up in the background while your subject remains the main focus, set in the foreground.

Barn exteriors aren't the only part of a farm that makes for good backgrounds. An open barn door or an old rusted gate can also offer unique options. Other elements such as a silo or out building might also work well. Additionally, many old farm buildings have great textures, ranging from peeling paint to weather-worn wood, that make for appealing backgrounds.

> The trick to using barns in your background is choosing how much of the barn to use.

Outbuildings can form attractive backgrounds in rural settings.

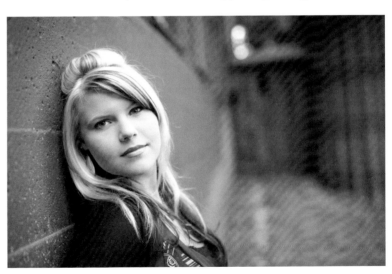

With corn stalks in the background, this small group was posed around a rusty gate.

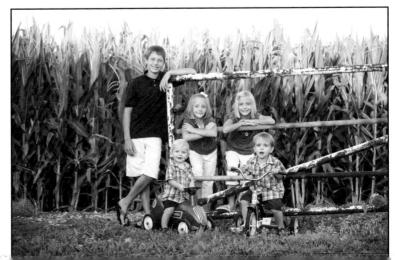

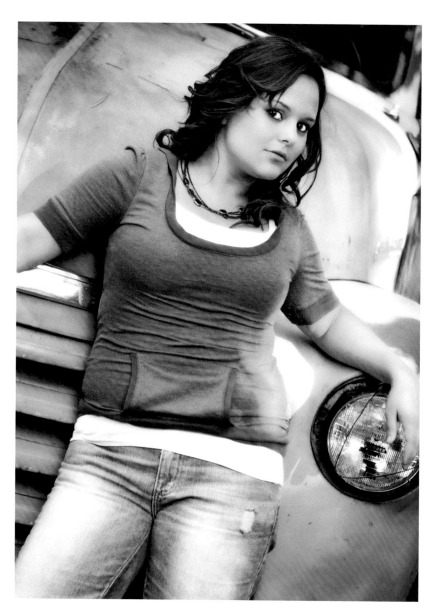

A weathered classic pickup was the background for this rural portrait.

"Rural" doesn't have to mean "farm." This category of background also includes paddock fences, open hay fields, country roads, abandoned vintage cars, and a plethora of other creative options. As a photographer, the challenge is seeing everyday locations as potential portrait locations. Sometimes we need to narrow our vision when looking at the landscape around us. If we're able to zero in on a specific area, perhaps we'll see something we've never noticed and recognize it as a useful background for portraits.

As a photographer, the challenge is seeing everyday locations as potential portrait locations.

Safety and Hazards

Safety in rural settings is no joke—especially if the farm is an old estate in disrepair. Keep an eye out for rusty nails, broken glass, broken boards, weak flooring, and crumbling concrete for starters. If conditions appear more modern, you should still watch for uneven ground, unexpected drop-offs, and other possible hazards. No matter where you are, it's your job as the professional photographer to make sure your shooting location is safe for your clients. They trust your expertise and assume you know what you're doing, so do your due diligence and scout the location first to keep your clients safe.

Get Permission

Get permission before shooting at locations that are not explicitly public. It should go without saying, but I know too many photographers who wander onto private property without

Safety in rural settings is no joke—especially if the farm is an old estate in disrepair.

Watch for hazards and take precautions to keep your subjects safe.

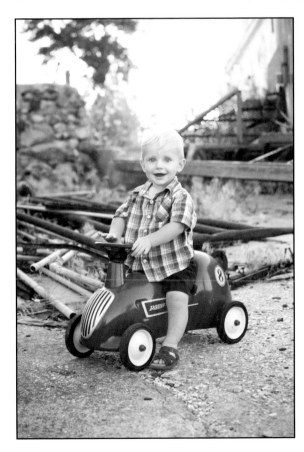

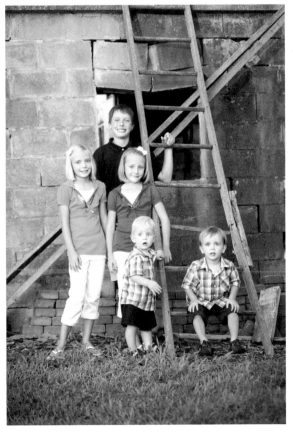

Always obtain the owner's permission before using a location.

hesitation. This behavior is not professional and your clients will take note. If you're shooting at the edge of a hay field at the side of a road, that's one thing. If you're traipsing across a field near someone's barn without permission, that's trespassing. Do the right thing and contact the landowner to ask for permission.

Most farmers I've approached about using their property for portraits have been gracious and willing—so long as we didn't ruin any crops or damage any property. As a thank-you, I always offer the owner a complimentary photo session. I've had some farmers turn down the offer, some who gladly accepted the family portrait, and others who preferred to receive a few nice photos of their farm and estate. As a result of those complimentary sessions, I've earned new clients and also forged strong friendships. As a bonus, I've been told I'm welcome on their land any time.

Some Great Rural Location Ideas

Apple orchards

Hay and wheat fields

Farms

Split-rail fences

Paddock fences

Lightly traveled country roads

Gravel roads

20. "Pro-pinions" on Location Backgrounds

Earlier in the book, I talked with a few professional photographers about their approaches to studio backdrops and backgrounds. I'm doing the same here—only this time the focus is on outdoor backgrounds. I spoke with Michelle Moore and with Shannon Sewell (whom I also interviewed for the studio section). They had some great insights to share and will hopefully provide you with food for thought when planning your own outdoor sessions.

Michelle Moore

■ WWW.MICHELLEMOORE.COM

Michelle Moore is a fashion and senior portrait photographer whose fashion experience and tastes often spill over into her senior work. The result is senior portraits that look like they belong in a glossy magazine. And that's one of the main reasons senior clients are booking her months in advance. Despite her successful fashion work, during this interview we focused mainly on her senior work.

Michelle prefers shooting in 100 percent natural light and uses wide apertures so her portrait work has an organic, soft, and romantic feel. She relies on two lenses to solidify that look and feel. "I love my primes, and I switch between my 50mm and 85mm as my main portrait lenses," she says. To make sure the eyes are always sharp, she typically sticks with f/2.8 to f/2.2, but she may occasionally open up to f/1.4 for a more dramatic shot.

When it comes to backgrounds for her outdoor senior sessions, Michelle is constantly on the lookout for new locations. "Many of the spots I frequent are places I found when taking a side street somewhere or going the back way to avoid traffic. It's amazing how many places you can find by just stepping off the beaten path," she says. She takes iPhone photos and makes notes about locations, similarly to what I suggested in chapter 15.

When scouting for new places to shoot, Michelle tries to visit the location at the exact time she plans on shooting there. If she can't go at the right time, she'll make a guess at how the location will look at different times of the day. She's had plenty of practice scouting like this,

Photos by Michelle Moore.

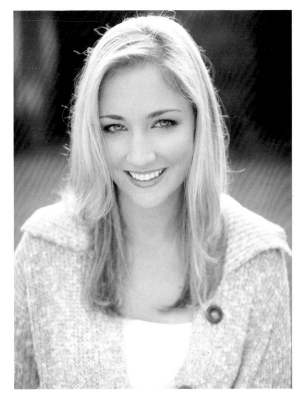 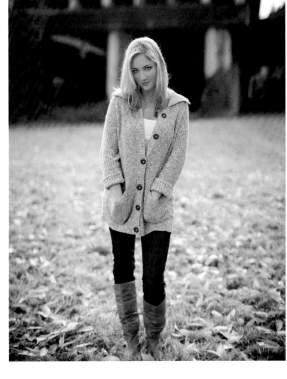

Photos by Michelle Moore.

so she's confident in her light-prediction skills. Scouting for Michelle is part previsualization and part session planning, but she doesn't fully start putting backgrounds and subjects together until the day of the shoot.

When she arrives at a location, the first thing Michelle assesses is the lighting. "I look for the best light, and then the best backgrounds within those bounds," she says. Defining her bounds by good lighting allows her to focus on specific options at the location. And since she likes to move around as she shoots, it's important that she knows she's within the best-light-boundaries while changing angles and position.

"I prefer mid-afternoon for most locations," she says about her favorite time to shoot. "But I have a handful of locations where the light is better in the morning. I mostly prefer bright, sunny days so I can work in open shade, but overcast days give me nice even lighting and I can shoot anywhere without the restriction of harsh shadows from the sun."

After assessing the light, Michelle looks for a few other things in a location:

1. A simple, colorful or textured background for shooting close-ups, headshots or three-quarter shots. If it includes shapes and colors to complement the subject, that's a bonus.
2. At least four different types of backgrounds within that area (for example, a brick wall, an ivy wall, a yellow wall, and a blue wall).

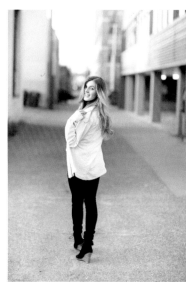

All five of these portraits were taken in essentially the same place. By moving around the model and changing her shooting position, Michelle was able to capture very different backgrounds. Photos by Michelle Moore.

3. Open shade in each area (or great places that will be backlit by the sun).

4. A location where the subject can interact with the background. For example, a set of stairs, a log on the beach, a fence, etc.

It doesn't make any sense to shoot eighty frames from the same camera position, so Michelle says she constantly moves around her subject. This approach makes it extremely important to have good background matter all around her subjects—almost 360 degrees around them. She specifically looks for a place where she can get several different poses without the images all looking like they were done at exactly the same spot.

Photos by Michelle Moore.

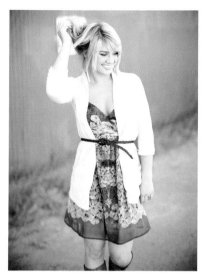 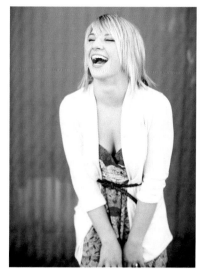

Michelle wants her portraits to have a timeless feel to them, so she avoids anything in the background that directly dates them. "I try to avoid people in the background, cars, garbage cans, and anything that could potentially be distracting to the final product," she says. "You don't want a telephone pole sticking out of your client's shoulder or a bright yellow road cone coming out of the corner of the frame. I look for places that add visual style to my portraits, but still remain focused on the client."

Another major consideration in Michelle's work is color. "I'll get a sense for what the client is going to wear at the beginning of our session and pick the spots throughout our shoot based primarily on what they are wearing," she says. "I keep the background simple, clean and complementary to their clothing choices so that everything has a cohesive look."

She doesn't want her portraits to feel forced or coerced, so she looks for locations that suit her clients' personalities to let them be themselves, with lots of movement and lots of action. Her goal is to tell a story, so she carefully considers each location to make sure the story is told.

Here's Michelle's advice on choosing good outdoor backgrounds:

Lighting—Does it have good light you can work with?

Variety—When working in one main location, make sure there are lots of options for that single shoot.

Safety—This is especially important when working with teens or children.

Permits/Private Property—Is the location public? Do you need a permit to shoot there? Sometimes locations require permits or permission from the owner.

How public?—Look for places that are safe, but not packed with people. Beaches are great, but make sure you won't be disturbing others—or make your client feel uncomfortable because there are nearby spectators. A crowded street probably isn't best for portrait work, either. Find a balance so your client is comfortable.

Shannon Sewell

SHANNON SEWELL PHOTOGRAPHY ■ WWW.SHANNONSEWELL.COM

As discussed in chapter 14, Shannon Sewell's style is unique and playful with a fairy-tale feel. That goes for her outdoor sessions as well.

Shannon lives in Portland, OR, but shoots all over the country. As a result, many of her sessions are in locations she's never visited and she doesn't always have the luxury of seeing her background options before shooting. Sometimes she will ask the client (or a friend in the area, if she has one) to go to a few spots they think would be appropriate and snap some photos. That way she can at least have a general

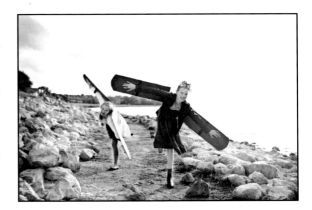

Photos by Shannon Sewell.

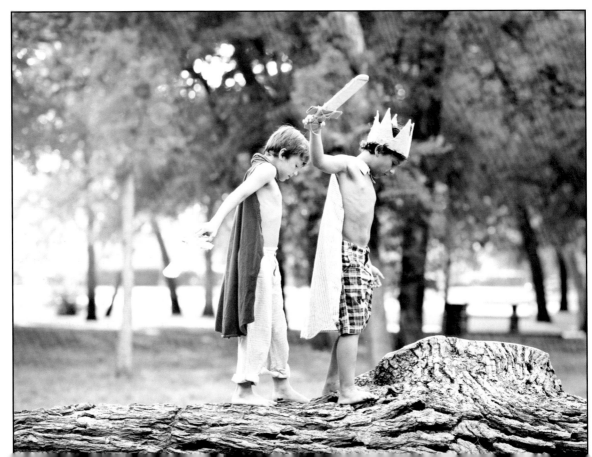

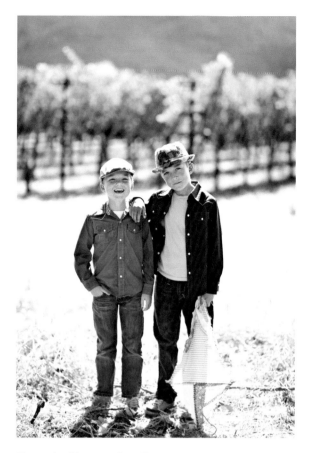

Photos by Shannon Sewell.

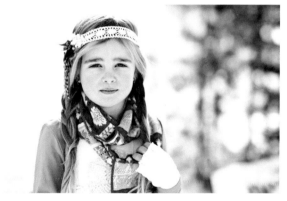

idea of the kind of setting she's preparing to shoot in. But she can't always get a snapshot of her locations prior to shooting at them, and that's okay. "Sometimes you get what you get," she says, "and that can be fun and challenging as well." No matter what, she can make a location work—she's always up for the challenge.

When choosing a location, Shannon likes things on the quirky side, so she stays away from the traditional park settings, which tend to be too "perfect." Instead, she says she looks for, "a place that complements the personality of my client and the story I'm trying to tell." It shouldn't be convoluted or garish. She says, "A place with good light and fun bits to incorporate in that story is really all you need."

Whether she's seen it beforehand or not, the first thing on Shannon's mind at a new location is the lighting—just as with her indoor portraits. While she often gravitates toward evening shoots for the golden-hour coloration and rim

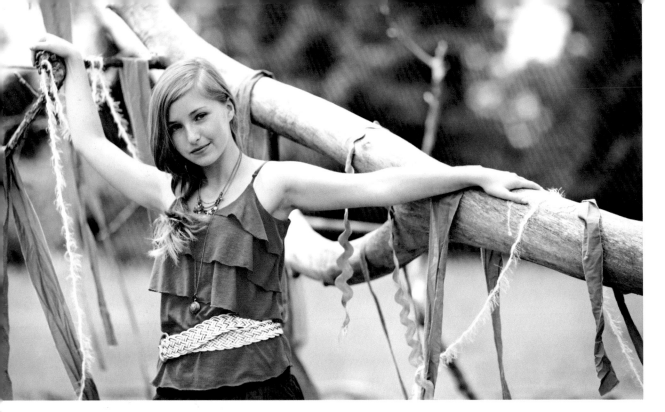

Photos by Shannon Sewell.

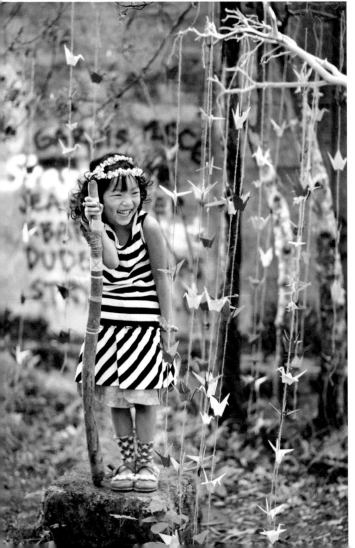

lighting, she doesn't limit herself to shooting only at that time. "I find when I'm shooting in the same lighting shoot after shoot, I start to get bored," she says. "Sometimes you have to switch it up from the golden, soft light to some harsh shadows to get the inspiration flowing." So no matter the time of day, she can—and will—make it work.

The next thing she's looking for is a clean background. Her outdoor portraits are light and colorful, so her background has to match in terms of the color (she shoots at very wide apertures, so the look of the background elements is less important than the color). She's also looking for leading lines and obstructive objects that might take away from the focus on her subject. Lastly, she looks for balance and

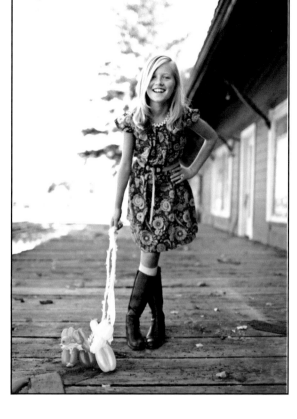

Photos by Shannon Sewell.

makes sure the composition complements the subject.

Once she's settled on a place to shoot, she adds her own personal touches that make the location unique to her—but she's adamant about keeping it simple. She says, "I like to do a lot of styling and adding to the feel of the shoot with what the client wears or has with them. But if you have too much going on, you lose sight of what you are trying to convey." She may add a few small props, or perhaps some strips of fabric for a look you wouldn't normally expect.

Then, she adds her own personal touch. Not only a visual personal touch, but a visceral personal touch. That's what differentiates her work from everyone else's. "I always put myself into my work," she says. "I add my personality, how I interact with my subject, and how I see the world. I am also telling *my* story when I shoot."

When tapping into her personal touch, Shannon often relies on colors to evoke feeling, and clothes and accessories to tell little stories about who her clients are. "Eccentric, simple, wild, reserved—it's like a stage costume that lets your audience in on what your character is all about," she says. That sense of play and storytelling comes through loud and clear in her photos.

Getting Uncomfortable

Photography and portraiture is about innovation and creativity. For studio work, I encourage you to experiment with different backdrops and to shoot with different backgrounds than you're used to. Shop at places you normally wouldn't, use patterns you're uncomfortable with. For location work, shoot at locations you're unsure of, places you wouldn't normally choose or ones that pose a challenge. It will be uncomfortable, but you will learn something through the process and that's never a bad thing.

Photography and portraiture is about innovation and creativity.

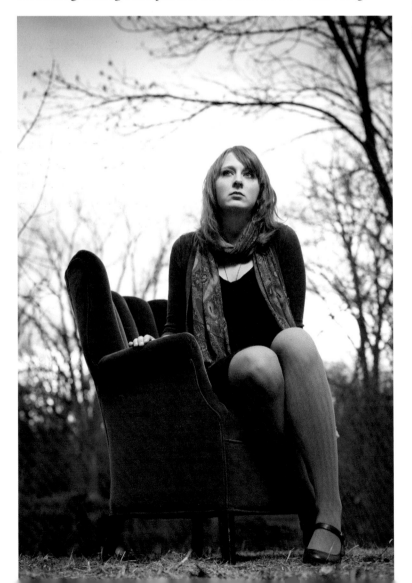

Acknowledgements and Contributors

Acknowledgments

First and foremost, I want to thank God. It sounds like a cliché, but I thank God not out of obligation, but out of appreciation and reverence. It is only because of Him that I have the ability and the opportunity to write this book.

Secondly, thank you to my beautiful wife Monica who appears in this book several times and who has no problem stepping in whenever I need a model. She's also my dream-chasing partner and the biggest proponent of my creative endeavors. Without her support and sacrifice, I wouldn't be where I am today, doing the things I love.

Contributing Photographers

Thank you also to all the contributors to this book. I truly couldn't have done it without you.

Jen Basford (3 Girls Photography)
www.3girlsphotography.com
Jen Basford is best known for her high-school senior portraits and the must-see fashion show she puts on for upcoming seniors each spring. She owns a 3,500-square-foot, custom-designed studio in Edmond, OK, and markets to a high-end boutique clientele. In fact, she has become one of the top senior portrait photographers in the Midwest largely due to her out-of-the-box approach to marketing and client relationships. Her love of senior portraiture and fashion-style photography has led her to develop an entirely new market at her studio: individual portrait studies for 'tweens. Besides Jen's love of fashion, she enjoys posting on Instagram, obsessing over pretty office supplies at russell + hazel, and Sonic's Diet Dr. Peppers. She is also the mother of three loud, crazy, dramatic, adorable, and slightly obnoxious little girls who are the namesake of her studio, 3 Girls Photography.

Gary and Pamela Box (Box Portrait Gallery)
www.boxportraits.com
Gary Box is known for his cutting-edge portrait style and as a leader and instructor in photographic technology. He has operated Gary Box Photography since 1989 and was one of the first portrait photographers in the country to start using the computer as a creative tool. He has written five books teaching other photographers his techniques, and teaches workshops all over the country.

Pamela Box owned and operated Kamies Portrait Gallery for ten years in Sioux City, IA, where her fresh approach put her studio in high demand. Pamela has won state and national recognition for her creative and artistic style. Pamela moved to Oklahoma in 2002, and married Gary soon after. They combined not only two families (Gary's two children and Pamela's three), but also two artists. The result was a powerful combination of creativity, style, and capabilities.

Stan Foxworthy (Foxworthy Studios)
www.foxworthystudios.com

Stan Foxworthy has invested more than thirty years in his craft. Extensively self-taught, Stan began his photography career in 1976 as a freelance photojournalist. Over the next three decades, he continued to hone his proactive photography skills shooting weddings, debutante balls, theatrical portraiture, products, and travel. His range of work showcases his diversity, and his images have graced the pages of numerous national publications, from the *Miami Herald* to *Vintage Motorsports*, with clients including Celestial Seasonings, Samsonite, Palo Duro Hardwood Floors, and Michelin North America.

Simon McConico and Jake Rohde (Valo Photography)
www.valophotography.com

Valo Photography is a duo of artists located in Milwaukee, WI. The combination of talents comes from photographers Jake Rohde and Simon McConico. Energetic, fun, and a little bit crazy, they approach everything they do with a fresh perspective and a set of new eyes (which, they note, gets pretty expensive—given the price of eyes these days). "Photography is something we have to do, it is something born in us, it is a passion, it is our lives," says Jake. "Taking this passion and sharing it with others has been an extraordinary experience." (The word "valo," by the way, is Finnish for "light," the basis of every photograph.)

Michelle Moore
www.michellemoore.com

Michelle Moore is a fashion editorial and senior-portrait photographer working in both Seattle and Los Angeles. She had the pleasure of shooting her first magazine cover last October with *90210* star Jessica Lowndes and has worked with many local and national magazines on editorial and celebrity assignments. Michelle loves helping high school seniors see their inner and outer beauty with her boutique-like portrait experience, and bringing awareness to healthy body image through her fashion and celebrity editorial work.

Shannon Sewell (Shannon Sewell Photography)
www.shannonsewell.com

"I believe the most important thing we can do is love and be kind," says Shannon Sewell, a children's photographer based in Portland, OR. "I found my perfect muse for this—and all I do—in my children. I have made a career of taking pictures of them (and playing dress up). When they let me, I dress up other people's kids and take pictures of them, too. I've got a hippy soul with a touch of OCD. I believe that animals are friends, not food, and I probably won't remember your name but I'll always remember your smile."

Jim and Ravyn Stadick (Jim & Ravyn Photographers)
www.jimandravyn.com

Ravyn Stadick is a portrait photographer and designer based in Portland, Oregon. In 2009, she started Jim & Ravyn Photographers with her husband—as well as Three Fifteen Design, an independent design studio. "Since then," she says, "we've focused on meeting rad clients and getting to know them as much as possible. We love photographing people in really cool locations and focusing on composition, light, and of course, the relationships between our clients. We absolutely love our job, and feel so lucky to be doing something we love so much."

Resources

You'll find dozens of backdrop and background manufacturers and re-sellers out there, but here's a list of suppliers that have both standard and unique offerings—everything from traditional muslins to sticky-back wall hangings.

Alba Backgrounds	www.albabackgrounds.com
Aura Backdrops	www.aurabackdrops.com
Backdrop Express	www.backdropexpress.com
Backdrop Outlet	www.backdropoutlet.com
Backgrounds by Maheu	www.backgroundsbymaheu.com
Barbour Backdrops & Props	www.barbourbackdrops.com
Colleen & Co. 4 Pros	www.colleenandco4pros.com
Denny Manufacturing	www.dennymfg.com
Design Revolution	www.designrevolutiononline.com
Dreamworld Backdrops	www.dreamworldbackdrops.com
Drop It Modern	www.dropitmodern.com
FJ Westcott	www.fjwestcott.com
LemonDrop Stop	www.lemondropstop.com
Orange Peel Backgrounds	www.orangepeelbackgrounds.com
PepperLu	www.pepperlu.com
Photo Prop Floors & Backdrops	www.backdropsandfloors.com
Photopie	www.photopic.com
Savage Universal Corporation	www.savagepaper.com
Shooting Gallery Backgrounds	www.shootinggallerybackgrounds.com
Silverlake Photo Accessories	www.silverlakephoto.com
Sky High Backgrounds	www.skyhighbackgrounds.com

Index

A

Adobe Photoshop, 46, 61
Architectural backgrounds, 121–27
 composition, 124–25
 defining locations, 121–24
 emotional connections, 121–24
 mood, 126
 what to look for, 126–27

B

Backdrop Outlet, 18, 37, 68
Backdrops, 8–9, 11–108
Backgrounds, 8–9, 109–53
Baseboards, 39–40
Basford, Jen, 105–8
Black backgrounds, 53–57
 backdrop color, 53–54
 lighting, 55–56
 postproduction, 56–57
 subject distance, 54–55
Blue screen, *see* Digital
 backdrops, chromakey
Box, Gary and Pamela, 99–104

C

Calumet, 64, 68, 76, 77
Canvas, 12
Choosing backdrops, 80–87, 104
 contrast, 104
 maintenance, 81–82
 material, 80
 portability, 83
 quality, 82
 size, 83
 storage, 81
 wrinkles, 81
Chromakey, *see* Digital
 backdrops, chromakey

Cleaning backdrops, 12–13, 17, 81–82
Composites, *see* Digital
 backdrops
Cotton blends, 12–13
Cyclorama walls, 49–52
 advantages of, 49–50
 lighting, 50–51
 maintenance, 51–52

D

Denny Manufacturing, 18, 37, 39, 68, 77
Digital Anarchy, 62
Digital backdrops, 58–63
 advantages of, 63
 chromakey, 59–63
 choosing, 61–63
 creating, 61–63
 design software, 62–63
 lighting, 59–61
 masking software, 61–63
Distance to subject, 14–15
Drop It Modern, 18–20, 65, 79

F

Fabric, 13–14, 66–67, 96, 106
FJ Westcott, 58–60, 68
Floordrops, 36–39
Flooring, 32–41
 all-in-one, 40–41
 backdrops as, 38
 baseboards, 39–40
 Dura Floors, 37
 floordrops, 36–39
 paneling, wood, 37
 permanent, 35–37
 storage, 38–39
 sweeps, 33–35

(Flooring, cont'd)
 Twin Drop, 40
Found objects, 89
Freedom Cloth, 18

G

Green screen, *see* Digital
 backdrops, chromakey

H

Hanging, *see* Setting up
 backdrops
Home store options, 37, 89

I

Infinity coves, *see* Cyclorama
 walls
Ironing, *see* Wrinkles

L

Lastolite, 68
Lighting backdrops, 42–48, 55–56, 69–74
 black, 55–56
 independently from subject, 70
 light modifiers, 72–74
 light positioning, 70–71
 metering, 70
 white, 42–48
Location photography,
 studio backdrops for, 12, 41, 64–68, 83
Location selection, 109–20, 121–53
 adding light, 117
 camera position, 113, 114, 124–25, 137
 cataloging, 110–11, 146

(*Location selection, cont'd*)
different looks at same location, 119–20
lens selection, 115 16
permission to shoot, 120, 137–38, 143–44, 149
perspective, changing, 115
safety, 137–38, 143, 149
scouting, 109–12, 146–48
subject position, 112–14
time of day, 117–19
types of backgrounds, *see* Architectural backgrounds, Natural landscapes, Urban landscapes, *or* Rural landscapes
what to look for, 111–12, 146–49

M
Masking software, 61–63
Materials, 11–20
McConico, Simon, 125
Mobile walls, 102–3
Moore, Michelle, 146–49
background color, 129
choosing backgrounds, 149
lighting, 146, 47
location scouting, 146–48
Muslin, 12–13, 35, 64, 65

N
Natural landscapes, 128–32
composition, 131–32
seasonal changes, 129
time of day, 130
trends, 132
what to look for, 130–32

O
onOne Software, 61

P
Painted backdrops, 21–23
Pantone colors, 9, 106

Platinum Cloth, 18
Polyester, 16–18
Portable backdrops, 12, 64–68, 83
advantages of, 65–66
collapsible, 66
for small studios, 66
making your own, 66–67
Prints/patterns, 84–87
Prom photos, 7–8
Props, 9, 90–91

R
Reflectance, 13, 18
Rohde, Jacob, 9, 127, 133
Rural landscapes, 139–44
barns, 140–41
permission, 143–44
safety, 143
what to look for, 139–42

S
Seamless paper, 24–31, 43–46
advantages, 25–26
setup, 26–27
sizes, 24–25
storage, 31
versatility, 29–30
white, 43–46
Setting up backdrops, 17, 27, 75–79
Antlers, 79
expansion drive mounting systems, 77–78
motorized roller systems, 78 79, 103–4
stands, 27, 66, 75–77
Sewell, Shannon, 94–98, 150–53
backdrop designs, 96
choosing backgrounds, 151–53
lighting, 151–52
location scouting, 150
personal touches, 153
storage, 98

Shooting Gallery Backgrounds, 80, 82, 84
Simply Canvas, 40
Size, 24–25, 64–66, 83–84
Stands, 27, 66, 75–77
Steaming, *see* Wrinkles
Storage, 13, 14, 15, 17, 31, 38–39, 66, 81, 98, 101–3, 108
Sweeps, 33–35

T
Trends, 84–87, 105, 132

U
Urban landscapes, 133–38
composition, 137
permission, 137–38
safety, 137–38
what to look for, 134–37

V
Vignetted backdrops, 23
Vinyl, 20

W
Washing backdrops, *see* Cleaning backdrops
Weight, *see* Portable backdrops
White backgrounds, 42–48, 49–52
cyclorama walls, 49–52
extracting subject from, 46
lighting, 42–48
seamless paper, 43–46
softbox backdrop, 47–48
subject placement, 45–46
White House Custom Color, 105
Wrinkles, 13, 14–18, 65, 81